IMAGES
of America
MILWAUKEE'S BRONZEVILLE
1900–1950

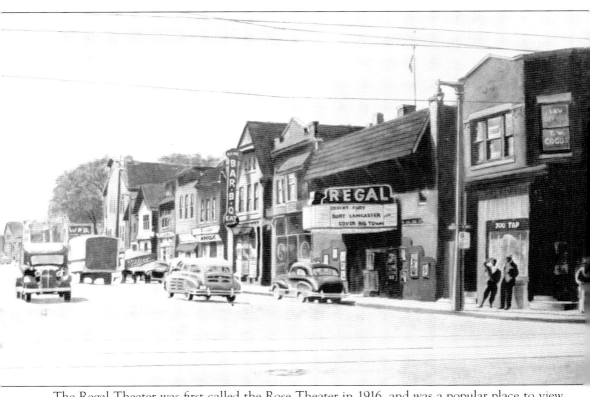

The Regal Theater was first called the Rose Theater in 1916, and was a popular place to view silent movies and Yiddish dance troupes. In 1938, it was purchased by partners James Dorsey, a successful African American attorney, and Samuel Ludwig, a Jewish businessman. It received extensive remodeling in 1938, getting a new marquee that extended over the sidewalk, luxurious red curtains, and a 40-foot-wide plush red carpet running down the aisles of the theater. On a Friday or Saturday night, after the late movie, the Regal held amateur jitterbug dance contests and other entertainment by local talent. These amateur nights were training grounds for pianists like Billy Wallace and other local artists such as Bunky Green, Willy Pickens, Phoenix Newborn, and Mary Young. The Regal was the place to be on weekends, children from the neighborhood could spend practically the whole day at "The Flicks," watching a triple feature of westerns and cartoons. (Photograph of charcoal drawing by Sylvester Sims.)

On the cover: The boys in the St. Benedict the Moor band pose on the steps of the chapel sometime in 1930s. Boys' bands were an integral part of the St. Benedict's tradition. Lionel Hampton, the jazz musician, got his early musical training in one of these bands. (Photograph courtesy of St. Benedict the Moor Church.)

IMAGES of America
MILWAUKEE'S BRONZEVILLE
1900–1950

Paul H. Geenen
Introduction by Reuben K. Harpole

Copyright © 2006 by Paul H. Geenen
ISBN 978-0-7385-4061-0

Published by Arcadia Publishing
Charleston SC, Chicago IL, Portsmouth NH, San Francisco CA

Printed in the United States of America

Library of Congress Catalog Card Number: 2006926359

For all general information contact Arcadia Publishing at:
Telephone 843-853-2070
Fax 843-853-0044
E-mail sales@arcadiapublishing.com
For customer service and orders:
Toll-Free 1-888-313-2665

Visit us on the Internet at www.arcadiapublishing.com

This book is dedicated to our son Michael Paul Geenen, who has connected us to people and places that have enriched our lives and forever changed our definition of community. I am so very proud of him and his perseverance through many challenges.

Contents

Acknowledgments — 6

Introduction — 7

1. Commercial Development: This Little Light of Mine — 11
2. Churches: There is a Balm in Gilead — 25
3. Schools: Freedom is Coming! — 39
4. Entertainment: Mine Eyes Have Seen the Glory — 57
5. Sports: Guide My Feet — 73
6. Family: Shall We Gather at the River? — 85
7. Employment: We Are Marching — 103
8. The Leaders: Lead Me, Guide Me — 115

Acknowledgments

The author wishes to thank those who made their historical photographs available, those who shared their memories about life in Milwaukee's Bronzeville, and those who helped with the historical research: Cheryl Ajirotutu, Aaronetta Anderson, Barbara Augenstein at St. Benedict the Moor Church, Lt. Stephen Basting at the Milwaukee Police Department Police Academy, Norma Benford, Clayborn Benson at the Wisconsin Black Historical Society/Museum, Edith Butts, Caroline Callier-Malone, Tim Cary at the Archdiocese of Milwaukee, Felmers Chaney, Elizabeth Coggs-Jones, Harriet Cox-Spicer, Bishop Sedgwick Daniels, Alma Eggert, Ellen Engseth at the University of Wisconsin-Milwaukee Libraries, Priscilla Franklin, Howard Fuller, Frank Gay, Fr. Mathew Gotschalk, the Greater Galilee Church, Edith Green, Reuben Harpole, Bob Harris, Chuck Holton, Ida Hortman, Jay Hyland at the Jewish Historical Society, Eddie Jackson, Sally Jackson, Ralph Jefferson, Harold Mason, Dester Martin, Fredrick Mathews, Lenore Mathews, Vivian Mathews-Beckley, Peggy Matlock, Virginia McKinney, Clarence Parks, Sheila Parrish-Spence, Tony Rhodes, Jodi Rich at the Pabst Mansion, Diane Sanders, Ethelen Sartin, Mary Savage-Mitchell, Lucilee Scott, Sylvester Sims, Bill Sullivan, Robert Thomas, Herbert Ware, Brian Williams-VanKlooster at the Humanities Department of the Milwaukee Public Library, the Walnut Street Social Group, Doris Wood, Mary Young, and many others.

INTRODUCTION

Lift every voice and sing…let us march on until victory is won
James Weldon Johnson 1871–1938

Milwaukee's African American population remained quite small in relationship to the total population of Milwaukee in the first half of the 20th century. In 1900, there were 862 African Americans in Milwaukee, and by 1950, the African American population had grown to 21,772, still only 3.42 percent of the total population of Milwaukee. An increase in migration from Mississippi and Arkansas after World War II caused the African American population to triple by 1960, to 62,458, increasing their percentage to the total city's population to 8.43 percent. The movement of people from the South tended to follow the railroad tracks. Since most of them were from the rural South, Chicago was seen by some of them as a city with "concrete grass," and a small percentage of the migrants stayed on the train to Milwaukee, a city seen as being smaller and more manageable.

Segregation forced the African Americans migrating from the South to live in a very confined area of Milwaukee. In 1930, this area was bounded by Highland Boulevard on the south, Walnut Street on the north, and ran east to west from Third Street to Twelfth Street. By 1960, this area had expanded to Keefe Avenue on the north, Juneau Street to the south, the Milwaukee River on the east, and to Twenty-first Street on the west. This was the area known as Milwaukee's Bronzeville.

Before World War I, many of the African Americans migrating north, especially those from the larger southern cities, had been prominent politicians, business people, and professionals. In 1900 in Milwaukee, however, employment opportunities for African American migrants were often limited to domestic work for the women and, for the men, jobs in the city's hotels, as gardeners, or footmen in the homes of wealthy European Americans, or wherever the work was hot, dirty, low-paying, and heavy, such as on the rail lines serving the city. Employers saw African American men as having "superior ability to endure heat," which gave them "an advantage over the white laborers" as Joe Trotter writes. Wages were low for domestic and personal service workers—$4 to $6 per week for women domestic workers and $6 to $7 per week for male service workers. This compares to the $14 to $20 per week a carpenter or a stonecutter earned in the early 1900s.

In the mid-1920s, African American men moved quickly out of personal service jobs into arduous, difficult, and low-paying jobs in iron and steel, slaughtering and meat-packing, tanneries, and building and construction. Occupational hazards included silicosis or tuberculosis for foundry

work, working distasteful jobs slaughtering animals and transporting intestines for meat-packing, and, in the tanneries, working in the beam house, where dry hides were placed in lime-filled pits to remove the hair. Joe Trotter writes that a tannery worker wore rubber from head to toe, because "that lime would eat you up." The fumes from this process were nearly intolerable. Pay for such jobs was $12.50 to $35 per week, an improvement over both the domestic and service rates and the $4 to $5 per week a Southern farmhand was paid at that time.

Milwaukee's Bronzeville is remembered as a good place to grow up in the first half of the 20th century. The pace was slower than today; as one former resident said, while recalling that folks slept out on their front porches when it was hot, "No one really locked their doors; the screen doors were held with just a hook. Everyone used the same kind of skeleton key to get in their front door."

The Southern migrants emulated this country's other immigrant groups in shaping their own community with hard work and entrepreneurship. In spite of the discrimination that kept African Americans at the bottom of the economic ladder and in segregated housing, in the mid-1920s, Bronzeville residents started creating their own service businesses, financial institutions, churches, self-help agencies, unions, sports, and entertainment options. By the 1930s, the Columbia Building and Loan Association, Ideal Tailor, and the first African American physician practices were established. The fact that African Americans were not allowed to patronize white restaurants and theaters stimulated the establishment of African American–owned nightclubs, taverns, and restaurants that attracted not only African American patrons, but also white patrons looking for exotic entertainment. These nightclubs and restaurants brought significant outside dollars into the cash-starved Bronzeville economy.

There were certainly hard times, too. African Americans were the first to feel the impact of the Depression, and by the early 1930s, it was not uncommon to see men begging on street corners or loafing in pool halls in Bronzeville. Many gave up hope of finding a job and turned to relief agencies for help. The replacement of African American domestics by European immigrants during the Depression of the early 1930s is just one example of the economic impact of two world wars and the severe contraction and then rapid expansion that whipsawed the economy of Bronzeville from 1920 to 1950.

In 1940, 51 percent of African American men were unemployed, with 29 percent of them actively looking for work, compared to the 13 percent of white men seeking work. The outbreak of World War II found many of the African American men in the armed forces, while the women found defense jobs at places like Allis Chalmers. After the war, African American women were replaced by white workers in the plants and again forced to take domestic service jobs, resulting in a reduction of their weekly income from an average of $44 per week to $20 per week.

As the northward migration continued, the African American population in Milwaukee grew from 8,821 in 1940, to 21,772 in 1950. This put tremendous pressure on housing in the Bronzeville area. Expansion to the east was blocked by the Milwaukee River and the Third Street shopping district, and expansion to the south was blocked by the light commercial district on Wisconsin Avenue. African Americans found new housing by moving to the north and west. The "seven block rule" was another cause of expanding Bronzeville boundaries. Initiated by the Church of God in Christ and followed by other churches, this rule dictated that new churches had to be at least seven blocks from any existing church of their own denomination.

St. Mark African Methodist Episcopal Church was the only African American church in Milwaukee from 1869 to 1900, but by 1920, Calvary Baptist, St. Benedict the Moor Mission and School, and the Church of God in Christ were serving the spiritual, social, and economic needs of African Americans in Bronzeville. These churches supported clubs and other social outlets to give the new poor families from the South an opportunity to mingle with the families already living in Bronzeville. They also established schools, employment agencies, and community social welfare agencies such as the Urban League and the Booker T. Washington Social and Industrial Center to serve the community. Women who worked as domestic servants brought in both cash contributions and donations of land from their employers for the benefit of their churches.

Another source of start-up capital in Bronzeville was the gambling game of "policy," or "the numbers game," which flourished from the late 1920s through the early 1940s. Policy was a part of the underground economy that involved other illegal activities such as bootlegging. It was nonviolent and funded the growth of taverns, nightclubs, and restaurants. Policy was similar to the state-run lottery games of today; bets as small as a penny could win $5 or even $100. During the Depression, $5 could feed a family for almost a month, and $100 could set you up for life. The profits from running a policy were loaned out to business owners and repaid with income generated by the jukebox and pool tables placed in the borrower's tavern.

The "black and tan" clubs were named for their attraction to both white and black audiences. The Metropole Club, which was started in the late 1920s, offered an exciting blend of jazz and blues. By the 1930s and 1940s, clubs like Club Congo, the Flame, Art's, and Moon Glow all took turns at being the place to be. Local bands were featured on weeknights, while nationally known groups played on the weekends. These clubs drew customers from the Bayside, Whitefish Bay, and Shorewood suburbs looking to eat, drink, listen to music, and patronize the records shops.

Social clubs, consisting of 8 to 15 members, rented the clubs on Sunday afternoons to hold "matinees," providing entertainment that ranged from amateur hours to nationally known entertainers. Some of these events were held for the purpose of providing a very high-class entertainment venue for the social club members. Social clubs raised money for such things as a spring dance at the Booker T. Washington YMCA, or to help those in need. Social clubs would sponsor and sell tickets to these matinees to members of other social clubs, who would attend each other's matinees. In 1953, there were 87 social clubs listed in the Negro Business Directory. At least one social club, the Walnut Street Social Group, still meets today.

The Urban League sponsored many of the baseball, basketball, and football teams and boxing events; but more important, they provided role models for the youth growing up in Bronzeville. Baby Joe Gans, the former lightweight champion of the world was one of the heroes in the African American community. Competition was fierce among the company-sponsored sports teams, and often a talented athlete would be hired just so that he could play on the company's team. Boxing was the only sport that offered those good enough the chance to reach the professional level.

Bronzeville was a place where African American families worked hard to make a living and to make a community. The men worked heavy, physical jobs during the day at a factory and then came home and worked the evening hours in their restaurant or in cleaning up their new church building. The women worked long hours as domestics to earn precious savings to start a new business or to make extra money to help their church grow. The children who grew up there went on to live out the lessons of hard work and community, long after the neighborhood itself was gone.

—Reuben K. Harpole

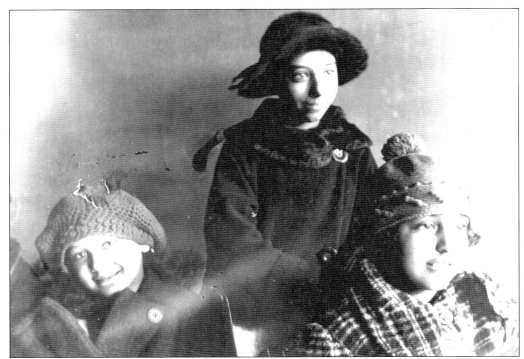

Three small children from St. Benedict the Moor Academy pose in 1923, dressed in their winter best, for a promotional photograph to be used for fund-raising for the school. (Photograph courtesy of St. Benedict the Moor Church.)

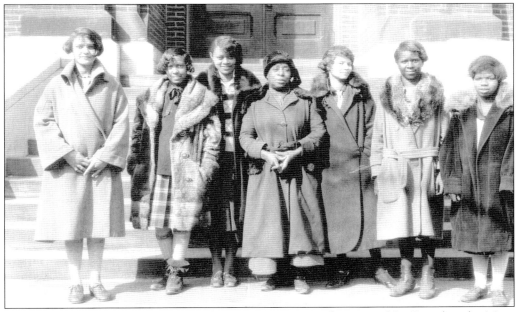

These young ladies proudly show off their winter coats on the steps of St. Benedict the Moor Chapel (Church). The photograph is undated but was probably taken in the late 1920s. (Photograph courtesy of St. Benedict the Moor Church.)

One

Commercial Development
This Little Light of Mine

Between 1915 and 1932, the increasing flow of poor migrants coming from the South needed rooming houses, inexpensive cafes, and a place to get a haircut. They patronized the African American–owned barbershops, restaurants, funeral homes, nightclubs, and taverns on Walnut Street, sometimes called "Chocolate Boulevard" by the unenlightened.

In the 1920s and 1930s, many Russian Orthodox and Reformed Jewish families also made their homes in the Walnut Street business district, establishing synagogues and such businesses as grocery stores, a bakery, a drugstore, and a deli. In the 1940s, however, Jewish residents of Bronzeville began moving west to Sherman Boulevard and were replaced by African Americans.

Most African American businesses were started with very little capital and supported by overtime work at a foundry by the men and extra domestic work taken on by the women. After coming to Milwaukee in 1924, Eugene Burns Mathews saved for 22 years before starting his Eighth Street Barbershop. He worked two shifts at the Falk Corporation, and later at A. O. Smith, then, with a loan from Columbia Savings and Loan in 1946, opened his first barbershop inside a drugstore at Eighth and Lloyd Streets.

Londy Cox, after a full day's work at Crucible Foundry, worked at his Northside Sandwich Shop until it closed at midnight. His daughter, Harriet Spicer (née Cox), opened the restaurant after school, doing her homework whenever business was slow. She says she was never late with her homework because she "could not afford to stay after school!"

Anthony Josey, editor of the *Wisconsin Enterprise Blade*, wrote many editorials advocating the support of African American businesses, believing they would create jobs for the youth of the community and present a viable alternative to the employment discrimination African Americans were encountering elsewhere.

Urban Renewal and the clearance of land for the freeway system in the 1950s and 1960s sounded the death knell for these African American businesses. The Hillside Redevelopment Project cleared the heart of the African American business district, and although some businesses relocated, most did not survive over the long run.

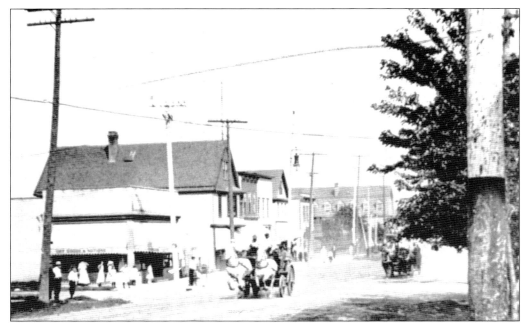

A pair of galloping white horses pulls a wagon down unpaved Walnut Street, before it was widened, while pedestrians wait to cross the street sometime during the early 1900s. There were 980 African Americans living in Milwaukee in 1910. (Photograph courtesy of Milwaukee Jewish Historical Society.)

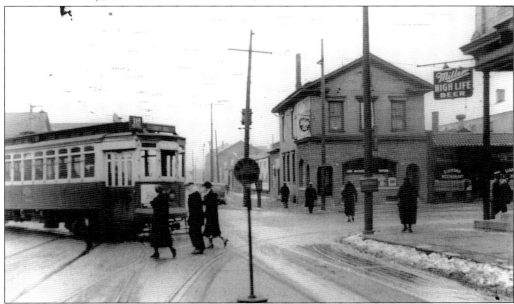

A streetcar heads south on Third Street after crossing Walnut Street on a chilly winter morning in this undated photograph. The Milwaukee County lines were thought of as being one of the best systems in the country. Quiet trolleys ran every 10 minutes, taking passengers to virtually anywhere in the Milwaukee County and running during the night for the second- and third-shift workers. (Photograph courtesy of Historic Photograph Collection/Milwaukee Public Library.)

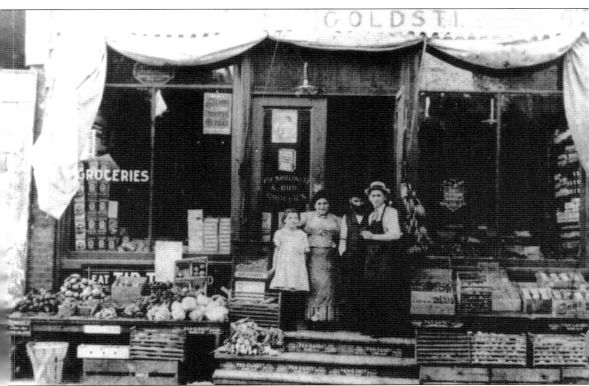

The Surlow (Srulouitz) family displays a fine selection of fresh vegetables and eggs sometime in the early 1920s. Corner stores were an important part of life in Bronzeville, "If our parents did not have any money, we still got what we needed from the store," one former resident said. "We would pick up what we needed and be told 'tell your Ma or Dad to pay me next week.'" Starting in 1910, Russian Jews from Eastern Europe immigrated to Bronzeville, living in the neighborhood with African American immigrants from the South. This began a relationship in Milwaukee between these two ethnic groups that continued through the 1960s civil rights movement to today. (Photograph courtesy of Milwaukee Jewish Historical Society.)

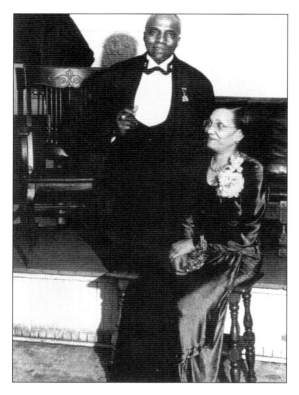

Anthony Josey was born in Augusta, Georgia, graduated from Atlanta University, and went to the University Of Wisconsin Law School. In 1925, he moved to Milwaukee and published the *Wisconsin Enterprise Blade*. As editor of the *Wisconsin Enterprise Blade*, Josey was a loud voice on issues that affected African American lives. (Photograph courtesy of University of Wisconsin-Milwaukee.)

Clarence and Cleopatra Johnson opened their tailoring shop in 1921, working closely together as partners and creating the first successful black business in Milwaukee. Clarence was one of the founding officers of the Columbia Savings and Loan, which opened in January 1925. Clarence Johnson is credited as being one of the founders of the Booker T. Washington YMCA on Eighth and Walnut Streets. (Photograph courtesy of Wisconsin Black Historical Society/Museum.)

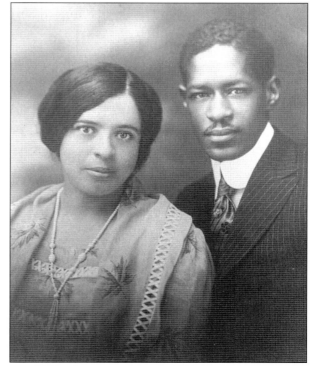

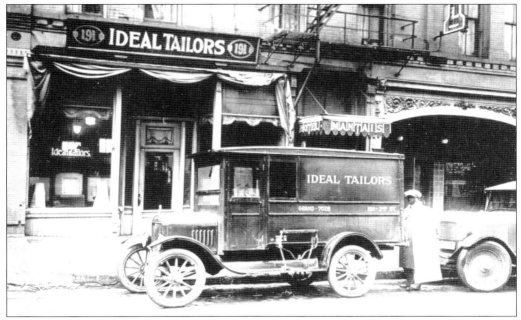

The Ideal Tailor Shop opened in 1921 when business dropped in the foundry in Beloit where Clarence was working. The Johnsons had difficulty getting white property owners to rent to them and initially leased the building shown here through a white intermediary. (Photograph courtesy of Wisconsin Black Historical Society/Museum.)

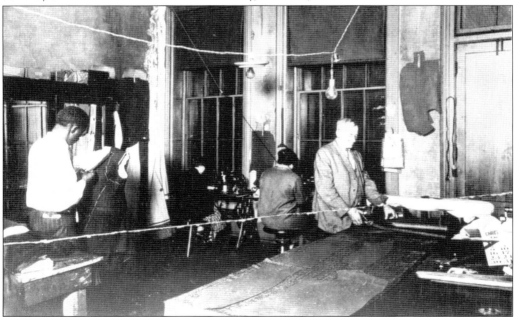

Cleopatra Johnson, the woman on the left with her back to the camera, works at the sewing machine in the Ideal Tailor Shop. Cleopatra also worked full time at the Johns-Manville Company for some time while Clarence focused on getting the tailor shop established. (Photograph courtesy of Wisconsin Black Historical Society/Museum.)

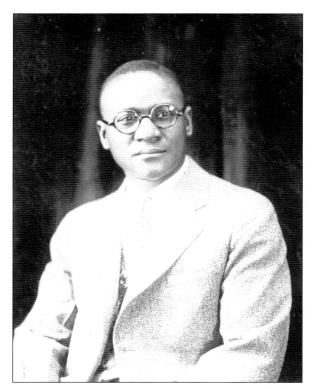

Wilbur Halyard was born in South Carolina and graduated from Morehouse College, and his wife, Ardie, was born in Georgia and graduated from Atlanta University. They married and moved to Beloit in 1920, where they managed a housing camp for workers at Fairbanks-Morse Corporation. In early 1923, they moved to Milwaukee, opening the Columbia Savings and Loan in 1924, the first financial institution to provide loans to Bronzeville residents. (Photograph courtesy of Lenore Mathews.)

Ardie Halyard started as a sorter in the production line at Goodwill Industries at 25¢ per hour in 1923, and rose to become the personnel manager of the organization, working there for many years. The couple made good business partners, with Wilbur managing the office during the day and Ardie doing the book work in the evening. She was a major force in both the local and national NAACP. (Photograph courtesy of Lenore Mathews.)

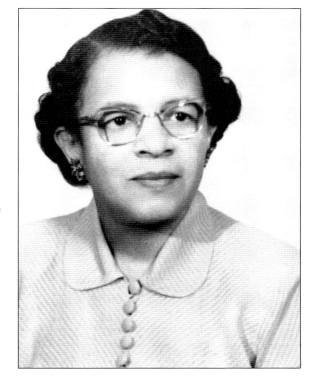

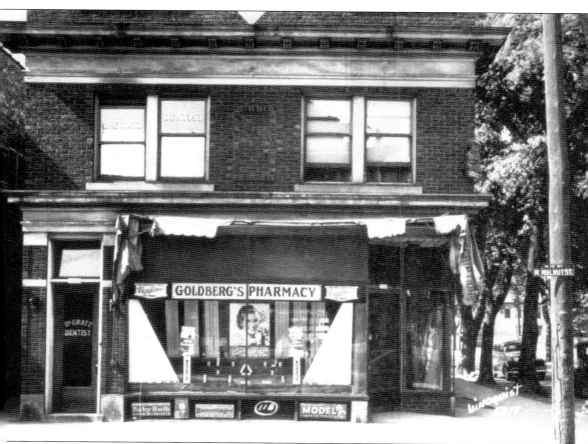

The Jacob Goldberg Drugstore, shown here in 1920 at Tenth and Walnut Streets, had a second-floor apartment where Vel Phillips grew up. In the early 1950s, after Vel Phillips wore out three pairs of shoes in a successful campaign to form a new Second District, she was elected as the first African American woman to serve on Milwaukee's Common Council. During her years of service on the Common Council, she worked diligently for fair housing laws and affordable housing. In 1968, after the summer riots of the previous year, the Milwaukee Common Council finally passed a Fair Housing Law. She was the first African American judge and the first African American Secretary of State in Wisconsin. (Photograph courtesy of Milwaukee Jewish Historical Society.)

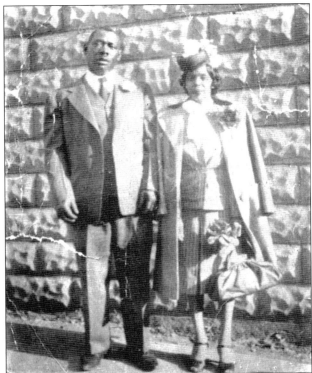

Londy Cox, left, worked during the day at a foundry and later in construction; after work, he ran his restaurant, the Northside Sandwich Shop. The restaurant, located at Tenth and Garfield Streets, was open until midnight. Londy and Anna's daughter, Harriet, opened the restaurant after school, running the restaurant and doing her homework during slow periods. Anna Cox did domestic work to help support the family business. (Photograph courtesy of Harriet Spicer [née Cox].)

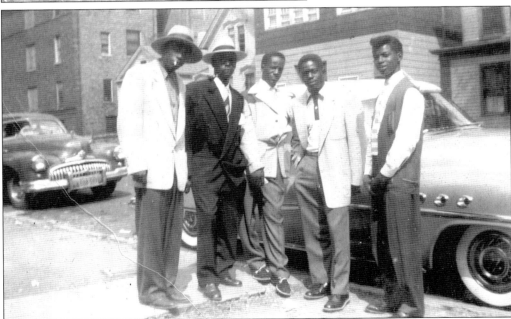

"The boys that came by" are in front of the Northside Sandwich Shop on Tenth and Garfield Streets, all dressed up for "Walnut Night." As described by participants, Walnut Night was a Saturday evening of cruising from Third Street to Twelfth Street in their 1950s Buick Roadmaster, complete with whitewalls. (Photograph courtesy of Harriet Spicer [née Cox].)

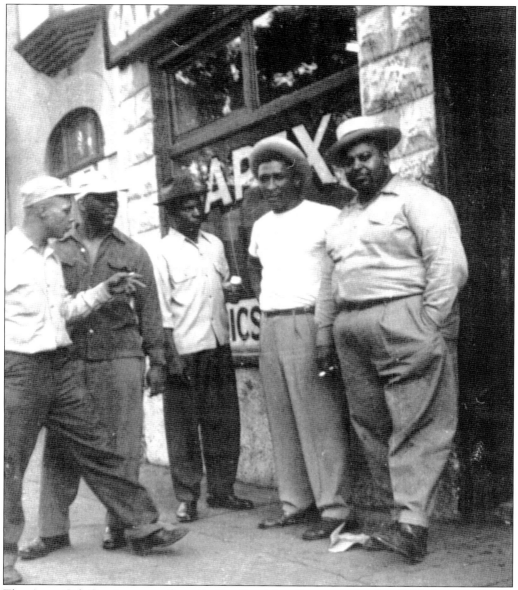

The Apex Cab Service was a front for Joe Harris's policy game. In this 1946 photograph are, from left to right, Albert Earl Harris, son of Joe Harris; Skeezik Estrada; Diz Adkins (who also was a ballplayer); Andy Lewis; and John ?. Bets were taken in pool halls, taverns, or alleys by policy runners. The runners received 25¢ for every $1 they took in on bets, and drawings were held twice daily, shifting from place to place to avoid detection. In the late 1940s, drawings were even done in moving cars. Sylvester Sims, a former Bronzeville resident, remembers visiting a friend at Thirtieth and Townsend Streets and seeing a policy wheel in the garage. It was unusual for an African American to be living that far from Walnut Street at that time. (Photograph courtesy of Aaronetta Anderson.)

Isaac Coggs (center) stands in front of his 700 Tap, a popular tavern in Bronzeville. Pictured with him are his daughter Elizabeth (left) and his wife, Marcia (in the doorway). Isaac, who also owned the Rendezvous and the Cross Town Tavern, began his education at Marquette University and finished at the University of Wisconsin-Madison after serving in the U.S. Army during World War II. (Photograph courtesy of Elizabeth Coggs-Jones.)

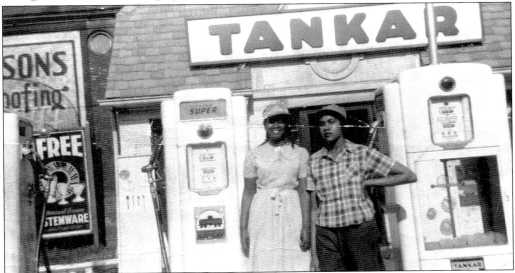

Doris Woods and a friend pump gas at the Tankar Station on Eighth and Walnut Streets. Woods's grandfather, Willis Crawford, owned the gas station. Motorists would pull up and buy 25¢ or 50¢ worth of gas to get them through the evening. (Photograph courtesy of Doris Woods.)

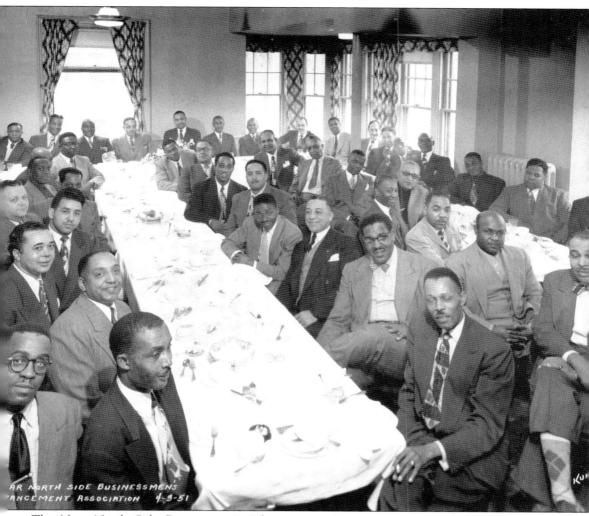

The Near North Side Businessmen's Advancement Association supported the growth of African American–owned businesses in the Bronzeville area. From 1940 to 1950, the number of African American–owned businesses almost doubled, growing from 109 to 210. According to the *Negro Business Guide to the State of Wisconsin* of 1950–1951, there were 170 boardinghouses, 35 taverns, 27 restaurants, 20 dry cleaners, 15 beauty shops, 12 barbershops, 12 grocery stores, 11 automobile repair shops, 11 fuel and ice companies, 10 painters, and three funeral homes in Milwaukee. Also listed in this directory were 26 ministers, seven attorneys, seven doctors, six dentists, 11 entertainers, and five orchestras. Isaac Coggs was president of the Near North Side group and used the networking potential of his office as a springboard to being elected to the Wisconsin legislature. (Photograph courtesy of Elizabeth Coggs-Jones.)

Eugene B. Mathews Sr. came to Milwaukee in 1920 as a semiprofessional baseball player for the Falk Foundry Industrial League team. During the war he worked as a welder at A. O. Smith and opened his first barbershop at Eighth and Lloyd Streets in 1946. A barber knows everyone in the community; Mathews raised money to help Vel Phillips attend college and persuaded Felmers Chaney to apply to the Milwaukee Police Academy. This photograph was taken in 1950. (Photograph courtesy of Frederick Mathews.)

From left to right, Frederick Mathews, Eugene Mathews, and George C. Mathews stand in front of Eugene's barbershop on Center Street. A master barber, he spent over 50 years in the profession and had shops on Third and Walnut Streets, Eighth and Lloyd Streets, Eighth Street and North Avenue, Twenty-seventh and Center Streets, and Teutonia Avenue and Center Street, sometimes with multiple shops open at the same time. (Photograph courtesy of Frederick Mathews.)

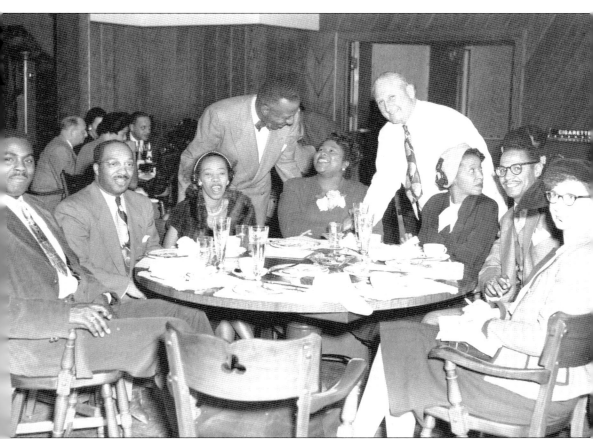

A group of notables sits at the front table at a Wisconsin Negro Directory affair held at Miller Brewing Company in October 1951. From left to right are Felmers Chaney (Milwaukee Police Department), LeRoy Simmons (first African American member of Wisconsin's Assembly), Mattie Belle Woods (social commentator for *Chicago Defender*), Rev. Cecil Fisher (Milwaukee County Probation Officer), Vernice Gallimore (Milwaukee Police Department), unidentified, Doretha Corter (Milwaukee County Social Worker), Hector Porter (State of Wisconsin Probation Officer), and Hannah Bilmiller (wife of a congressman). (Photograph courtesy of Lenore Mathews.)

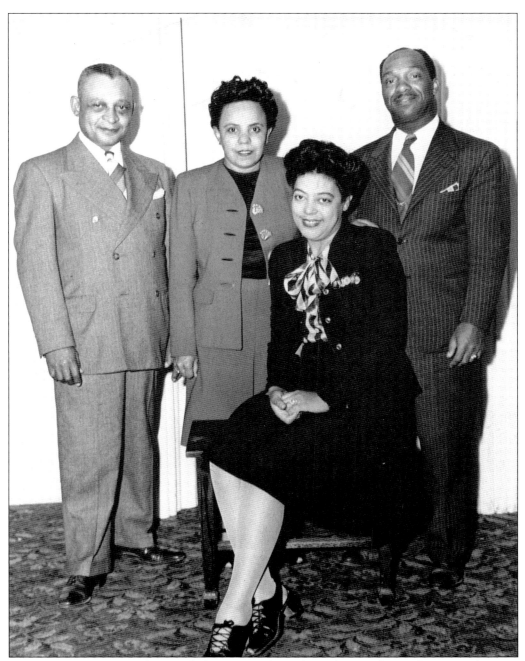

Business owners got together regularly to network, as shown here at the Booker T. Washington YMCA in the late 1940s. Jean Hendricks, who owned the Hendricks's Drug Store with her husband, is seated in front. Standing left to right are Harry and Clara Turner, owners of Clara's Restaurant, and LeRoy Simmons, member of Wisconsin's Assembly. Simmons was the first to openly run as an African American and ran a campaign attracting both black and white voters. A realtor, he received the endorsement of the Democratic Party and won with 50.6 percent of the vote against two white candidates. (Photograph courtesy of Lenore Mathews.)

Two

Churches
There is a Balm in Gilead

On January 9, 1869, Rev. Theodore Crosby met with eight others to form St. Mark African Methodist Episcopal Church, the first African American church established in Milwaukee. In 1914, after 31 years at Fourth Street and Cedar (Kilbourn) Street, St. Mark African Methodist Episcopal Church moved into a former German Reform Church and worshiped there until 1953. Two more moves occurred in the 1960s, forced by freeway construction, until they settled in at their present location, 1641 West Atkinson Avenue.

Calvary Baptist Church began on Seventh Street in 1895 as a small mission church led by the Reverend J. D. Odom. Moving and growing over the years, the congregation moved to its present location at 2959 North Teutonia Avenue in 1971, where it is known for its music and such social action missions as establishing housing programs for the elderly, providing food programs for the poor, and being part of the group that founded the first African American bank.

St. Benedict the Moor Mission, founded by Captain Lincoln C. Valle in 1908, held worship at two small storefronts (274 Fourth Street and then 530 State Street) until the Capuchins accepted official responsibility for the mission in 1911 and purchased the present property on Ninth Street. An elementary school and a high school opened in 1912 and 1923 respectively, and a new church was completed in 1924.

The Church of God in Christ denomination in Milwaukee began with the 1919 visit of a minister named Elder Robert Anderson, who arrived from Detroit with his family and moved into a local park to live. From that humble beginning, the congregation grew, and services were moved from homes to a converted fish market at Sixth and Vliet Street, and then to a storefront at Tenth and Galena Streets. The Church of God in Christ organization has grown to become the largest Pentecostal African American organization in the city.

Greater Galilee Baptist Church was founded in April 1920 at 838 West Vliet Street with the mission of "saving souls and providing a better quality of life for all." They moved to 808 West Walnut Street in 1942, and into their present building, a former synagogue at 2432 North Teutonia Avenue, in 1963.

Doctors and lawyers lived in the same neighborhood and went to the same churches as laborers and the unemployed. Even after open housing laws enabled those who could afford it to move elsewhere, many of the more affluent professionals continued to attend and support their home churches where their families had been for generations.

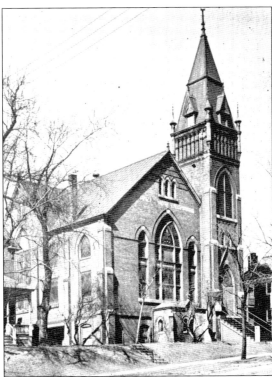

After 31 years at its first location, St. Mark African Methodist Episcopal Church purchased this building in 1914, at 1525 North Fourth Street between Cherry and Galena Streets, from a German Reform congregation. (Photograph courtesy of St. Mark African Methodist Episcopal Church.)

The St. Mark African Methodist Episcopal Church Senior Choir poses for a photograph in 1928. Singing in the choir offered congregation members the opportunity to participate in the worship service, exercise their creativity, and socialize with friends. (Photograph courtesy of St. Mark African Methodist Episcopal Church.)

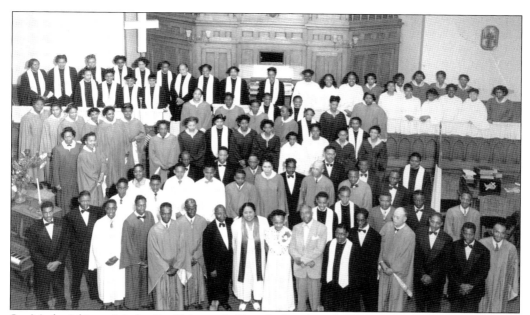

St. Mark African Methodist Episcopal Church Combined Choirs fill the entire sanctuary for a picture in 1948. The congregation worshiped 39 years in this, their third church home; 10 years later, the Milwaukee County Redevelopment office notified the congregation that they would have to move to make way for the new freeway. (Photograph courtesy of St. Mark African Methodist Episcopal Church.)

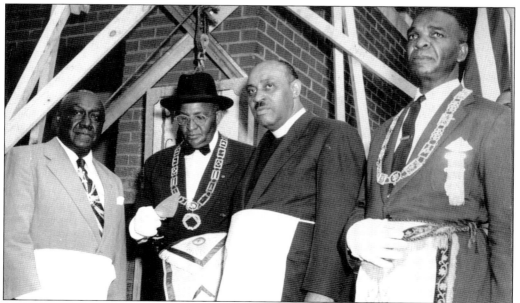

With much pride and care, the pastor and Masons from the Prince Hall Masonic Center lay the cornerstone for their new church at 1641 West Atkinson Avenue in 1953. Those laying the cornerstone are, from left to right, unidentified; Carlson Gulley, most worshipful grand master (in 1953); Rev. John Bradford, pastor of St. Mark's Church; and Gov. L. Glover, past grand master. (Photograph courtesy of St. Mark African Methodist Episcopal Church.)

Greater Galilee's first church was at 838 West Vliet Street. As soon as Greater Galilee opened its doors in April 1920, the congregation immediately made plans to raise $40,000 and expand, according to Joe Trotter. (Photograph courtesy of Greater Galilee Church.)

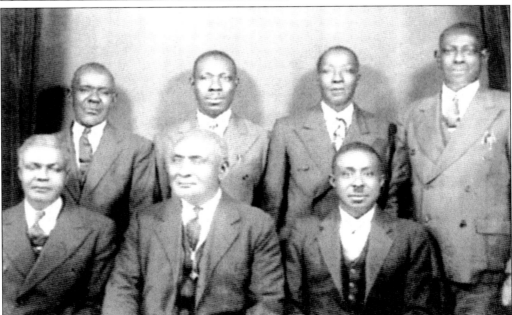

The Greater Galilee Board of Deacons posed after a deacons meeting on a Sunday, sometime in the 1920s. As recorded in their history, they shared the responsibility to fulfill a mission as "a church dedicated to the saving of souls and providing a better quality of life for all." (Photograph courtesy of Greater Galilee Church.)

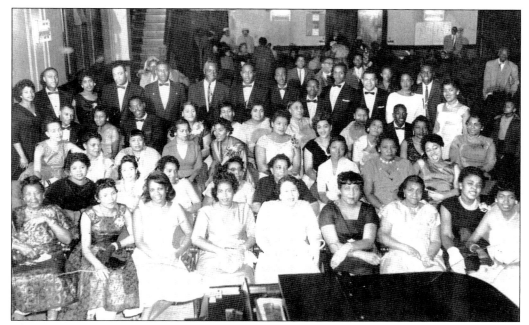

The Greater Galilee Choir is seen here in the second church, at 808 West Walnut Street, sometime in the mid-1940s. Dr. Sudie Tatum sits in the middle of the front row, Bernice Toney sits in the second row, third from right, and Juanita Virgil sits in the second row on the left. (Photograph courtesy of Greater Galilee Church.)

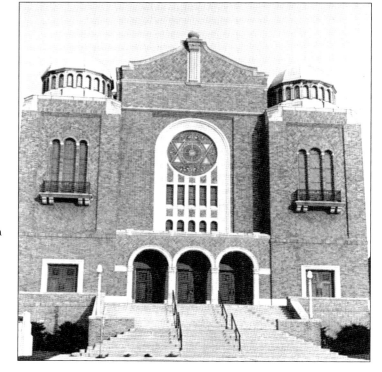

The Greater Galilee Church is seen here at its present location, 2432 North Teutonia Avenue. The congregation purchased this former synagogue in 1963 and recently remodeled its sanctuary. It describes itself as "The church with a heart for the heart of the city." (Photograph courtesy of Greater Galilee Church.)

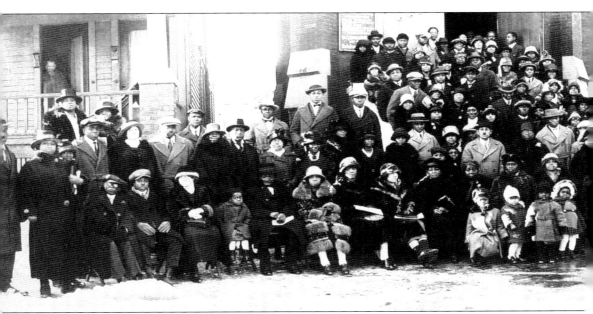

The Calvary Baptist congregation lines up on a winter day outside its third church at 1727 North Fourth Street after Sunday service around 1925. Mr. Rush, third from the left, sits in the front row, and James Mason sits next to him. The young boy standing in the first row on the right is Cornice Grace, the first African American from Milwaukee to lose his life in the Pacific during World War II. In the rear row, beneath the woman in the doorway, is Mr. Minor, and next to him is Mr. Williams. Mr. Shannon, with derby hat and mustache, stands in the third row, third from right. Mr. Guerins stands at the very top of the church steps, near the edge of the door; he is the tallest man wearing glasses. (Photograph courtesy of Harold Mason and Calvary Baptist Church.)

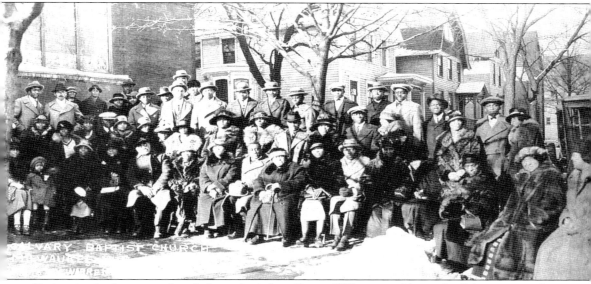

Sitting in the front row, fourth from the left, is Pastor Williams and his wife. Other points of interest are the cab of a car, seen on the right side of the photograph, and the parsonage to the right of the church. The church celebrated its 110th anniversary in October 2005. According to the anniversary program, the celebration honored the "many upon whose shoulders we stand," in a long and proud tradition of service. The congregation commissioned Glenn Burleigh, the talented pianist, composer, and conductor, to produce a new work to commemorate the event. The work features Burleigh's characteristic fusion of anthem, classical, and gospel styles. (Photograph courtesy of Harold Mason and Calvary Baptist Church.)

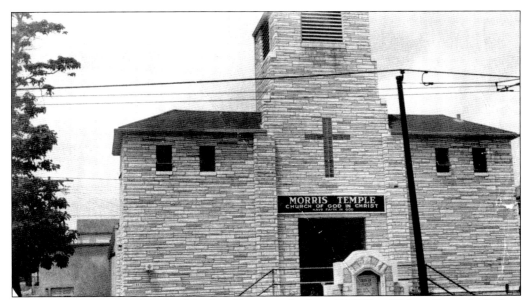

The Morris Memorial Church of God in Christ was built at 1035 West Walnut Street by Bishop W. L. Morris in May 1942, and was the first church built from the ground up by African Americans in Milwaukee. Reuben Harpole sold advertisement booklets on Galena Street for 10¢ to help raise money for this church. The church was torn down to make room for the Hillside Housing Project. Church of God in Christ is the largest African American Pentecostal denomination in the city. (Photograph courtesy of Ida Hortman.)

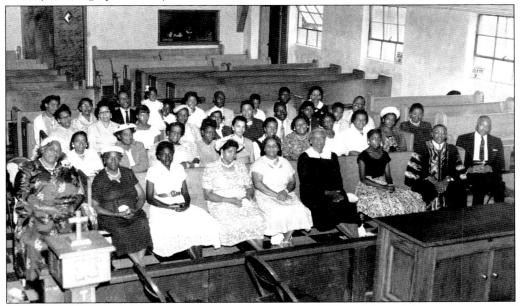

The congregation enjoys its first service, in the spring of 1952, at Morris Memorial Church of God in Christ where it was rebuilt at 1441 West Seventh Street after freeway construction caused the original church building to be razed. The congregation had worshiped in the basement for several years before they raised enough funds to complete the church. (Photograph courtesy of Ida Hortman.)

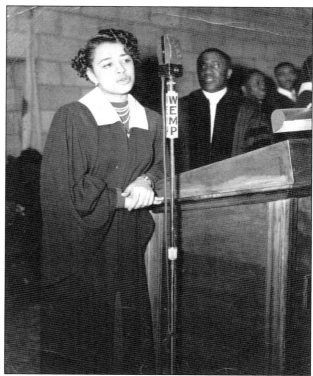

Sister Beason praises God in song over WEMP radio in 1945 while Bishop Morris watches behind the lectern. Sister Beason was known for her strong, talented voice. (Photograph courtesy of Ida Hortman.)

The Radio Choir from Morris Memorial Church of God in Christ poses before Sunday services. Minister Garnett Herron is sitting on the left side of the photograph. It was he, along with Elder Albert Tenzy, who nominated Overseer Morris to be consecrated to the bishopric in 1945. (Photograph courtesy of Ida Hortman.)

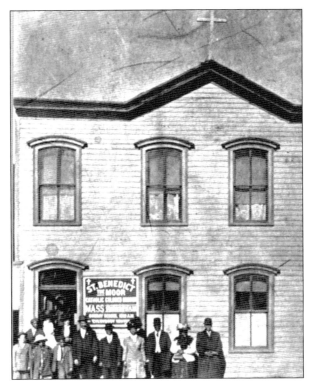

In August 1908, Capt. Lincoln C. Valle established the first St. Benedict the Moor mission in a storeroom at 272 Fourth Street. The new church had bare walls, not a stick of furniture, and no lights. The nearby Methodist church lent the new mission some chairs so that members could have seats during Sunday service. (Photograph courtesy of the Archives of the Archdiocese of Milwaukee.)

The second St. Benedict the Moor mission was rented at 530 State Street in June 1909 at a cost of $40 per month. Archbishop Messmer named and dedicated the church upon moving into the new facility. On August 7, 1911, Samuel Bryant and Mamie Pettis became the first Catholic couple to be married in this church. (Photograph courtesy of the Archives of the Archdiocese of Milwaukee.)

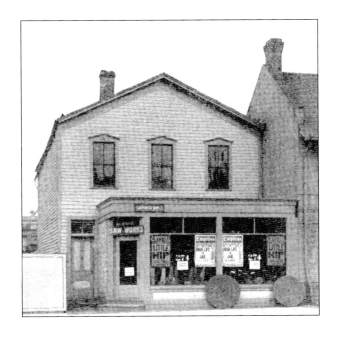

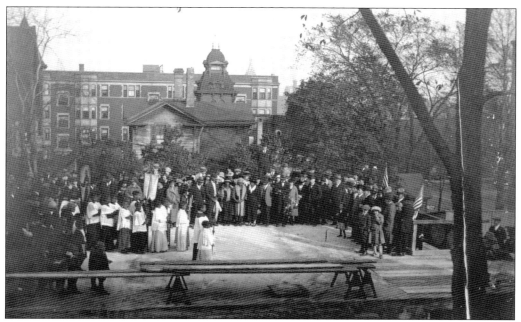

The ground breaking for the new St. Benedict the Moor Chapel at 311 Ninth Street (now 1041 North Ninth Street) is pictured here. The cornerstone of the church was set on October 7, 1923, by a missionary who had spent 46 years in Africa. (Photograph courtesy of St. Benedict the Moor Church.)

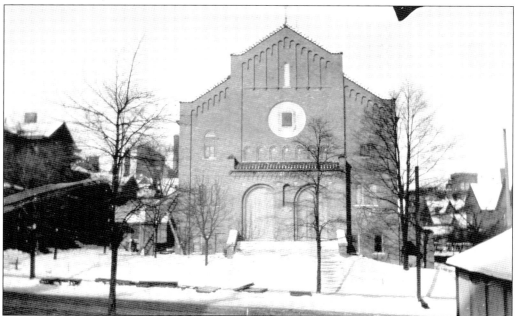

St. Benedict the Moor Chapel is seen in 1928. The entire cost of this church was donated by Ernest G. Miller, president of the Miller Brewing Company. St. Benedict the Moor was "a humble and sainted disciple of St. Francis," according to a 1912 history of the St. Benedicts the Moor Church. (Photograph courtesy of St. Benedict the Moor Church.)

Capt. Lincoln C. Valle came to Milwaukee from Chicago, Illinois, on August 25, 1908. A 1912 history of St. Benedict the Moor Church states, "It was his intention to spread the Church among his own race, to make known Jesus Christ to his poor colored brethren, to show them the treasures contained in the Catholic Church." (Photograph courtesy of the Archives of the Archdiocese of Milwaukee.)

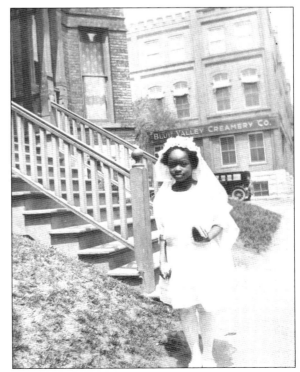

A second or third grader poses for her first communion picture in front of the rectory in the spring of 1925. (Photograph courtesy of St. Benedict the Moor Church.)

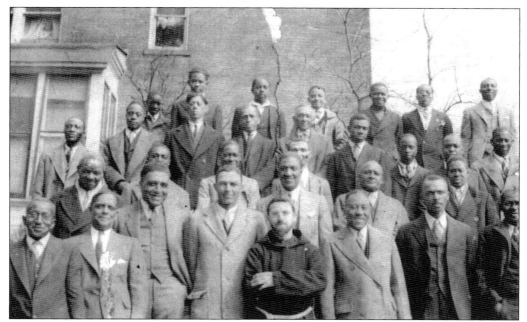

St. Benedict the Moor Holy Name Society is seen here in the early 1930s. Attorney James Dorsey is pictured in the first row, third from left; Bob Baker, Sylvester Sim's uncle, is fourth from left; Fr. Phillips in the center; and Granville Sims, Sylvester's father, is second from right. (Photograph courtesy of Sylvester Sims.)

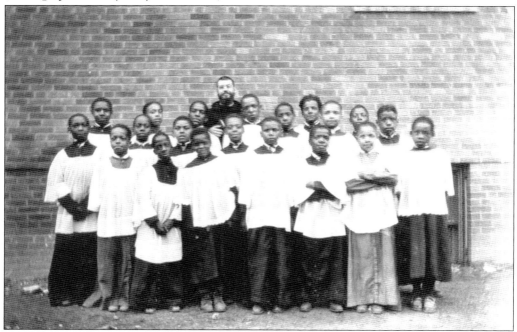

Altar boys at St. Benedict the Moor Chapel had to learn by rote the Latin responses to the prayers said by the priest saying mass. Not knowing what the prayers meant made this an especially daunting challenge. (Photograph courtesy of St. Benedict the Moor Church.)

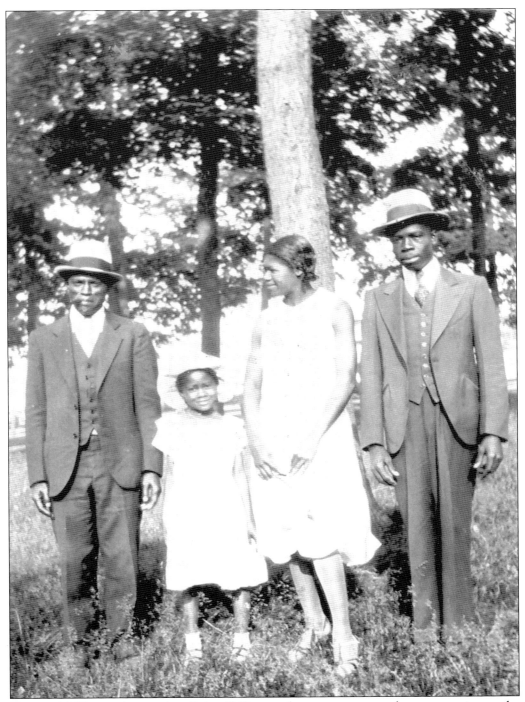
Virginia McKinney, her mother Daisy Collins, and two young men who were staying at the Collins' home at the time, pose at the "All Churches" picnic at Lake Park in the early 1930s. This was an annual event where members of all the African American churches got together for fellowship in Lake Park. (Photograph courtesy of Virginia McKinney.)

Three

SCHOOLS
FREEDOM IS COMING!

In the days of Milwaukee's Bronzeville, the forces of segregation kept the African American students of this tight-knit community within the boundaries of 10 schools: Fourth Street (now Golda Meir), Siefert, Lloyd Street, St. Francis, Ninth Street, Roosevelt Junior High, St. Benedict the Moor, Lincoln High, North Division High, and Girl's Tech.

Most of the teachers were unmarried white women, since once a woman married she was not asked back, and there were few attempts to hire African American teachers. The teachers were strict taskmasters who, according to Reuben Harpole, "took no stuff."

While several of the schools were predominantly black, others, such as St. Francis and Siefert, had only a few black students. One graduate of St. Francis described this experience as feeling like "a fly in buttermilk." St. Benedict the Moor was the only Catholic boarding school for African Americans in the country. Many of the students came from Chicago, and others, often the children of movie stars or professional sports figures, came from all over the country. The school also provided free education to local children.

Students going into the building trades or service industries went to Milwaukee Technical School, usually going to school at night and working in one of the factories during the day. In the 1930s, young men went to Civilian Conservation Corp camps and worked for $30 a month, often sending half of that back home to help support their families in Milwaukee. During the World War II labor shortage, young men could go to work at 15 if they went to vocational school one day a week. "You had to have a job to leave school," Lenore Mathews recalls, so the girls tended to stay in school longer than the boys.

Bronzeville watched over the neighborhood children, Chuck Helton remembers. "Your deportment and manners were overseen by the entire community." In a 2006 *Milwaukee Journal* article, former Bronzeville resident Ralph Jefferson remembers smoking a cigarette with a friend on Walnut Street and being scolded by his mother for it by the time he got home.

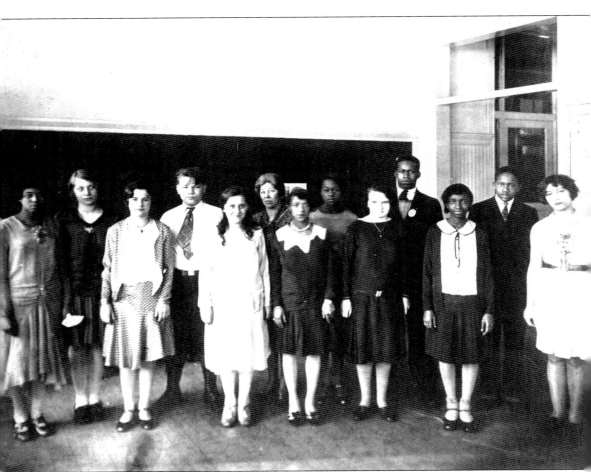

Miss Chorine Standish keeps a strict and watchful eye on her eighth-grade graduation class at Fourth Street School on January 31, 1931. Mary Young, a talented dancer who later married band leader Bernie Young, is in the front row, second from the right. After graduation, Mary went to the Vocational School at Nineteenth Street and Wells Street for less than a year, while dancing in late night amateur contests at local theaters where she always took first or second place. In 1932, she dropped out of school at the age of 18, joined the Ida Cox Vaudeville show full time, and went on her first road trip to Detroit. (Photograph courtesy of Mary Young.)

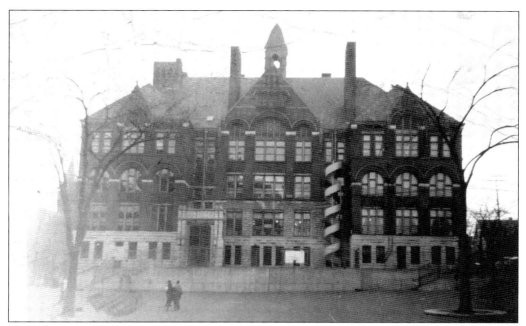

The majority of the African American students went to the Milwaukee Public Schools of either Fourth or Ninth Street. The Ninth Street School, shown here, was torn down in the 1960s for construction of the freeway. (Photograph courtesy of Larry Miller.)

The five girls standing in the second row at the third grade, B section Ninth Street School class are, from left to right, Barbara Washington, Lettie Phelps, Sally Jackson (née Riley), Lois Wade, and Shirley McHenry. Most of the teachers at Ninth Street School were white. (Photograph courtesy of Sally Jackson [née Riley].)

Miss Chorine Standish prepares the 1942 eighth-grade class at Fourth Street School for their important high school years. Although the photograph is not very clear, Miss Standish looks like she has relaxed a little over the last 11 years. (Photograph courtesy of Bob Harris.)

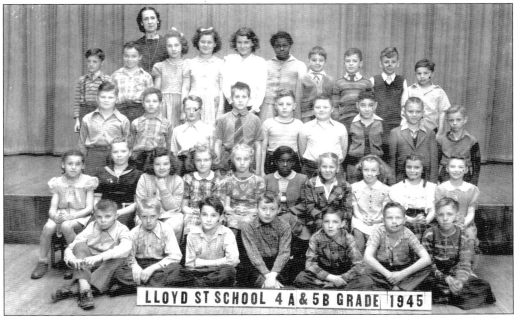

Harriet Spicer (née Cox) is shown in the middle of the second row, in her fourth-grade class, in 1945. Harriet remembers her teachers as being strict; this teacher looks like she fits this description. (Photograph courtesy of Harriet Spicer [née Cox].)

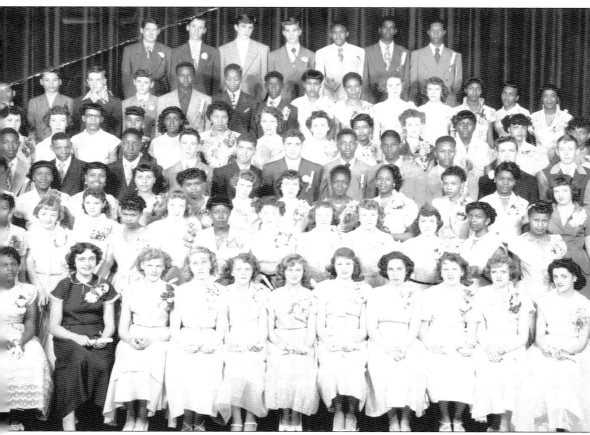

Harriet Spicer (née Cox) is the fifth girl from the left, the third row down, in this Roosevelt Junior High school class picture. She says she always did her schoolwork and avoided detention, since she had to open her father's restaurant, the Northside Sandwich Shop after school. (Photograph courtesy of Harriet Spicer [née Cox].)

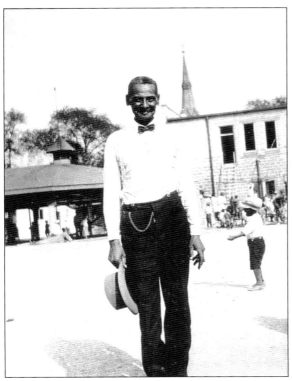

Capt. Lincoln C. Valle, dressed to the nines in the early summer heat, is shown on playground supervision in 1912. Standing behind the captain is a cute little guy in knickers and a soft hat, waiting for a ball to be thrown. (Photograph courtesy of St. Benedict the Moor Church.)

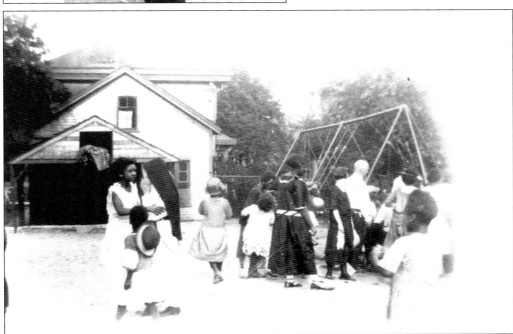

The kids line up for the swing behind St. Ben's while a Dominican sister comforts a girl on the playground in this 1923 photograph. It must have been hard to swing without losing one's hat. (Photograph courtesy of St. Benedict the Moor Church.)

A poster advertises lectures for "both adults and children" given by the Jesuits from Marquette University at St. Benedict the Moor Mission Chapel on State Street in the summer of 1914. (Photograph courtesy of St. Benedict the Moor Church.)

ALL WELCOME!
BRING YOUR FRIENDS

EVENING LECTURES
AND
CHILDREN'S MISSION
By the Jesuit Missionary Fathers of Marquette University.

ST. BENEDICT'S MISSION CHAPEL
10th and State Streets
Thursday, Friday and Saturday
JULY 23d, 24th and 25th

EVENING LECTURES AT 7:30 P. M.
THURSDAY—Outside the Catholic Church No Salvation.
FRIDAY—The Catholic Church and the Bible.
SATURDAY—Christ and Confession.

Children's Mission Each Day
9 A. M. till 3 P. M.

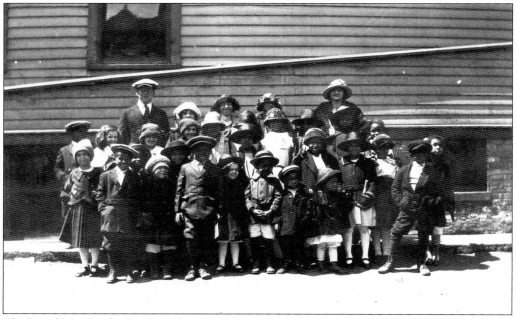

The boarding school at St. Benedict the Moor was started in September 1913 with two students. By 1914, when this photograph was taken, there were 36 students living at the school. These spiffed-up boarders, most wearing dress hats, ranged in age from three on up to 12 or 14. (Photograph courtesy of St. Benedict the Moor Church.)

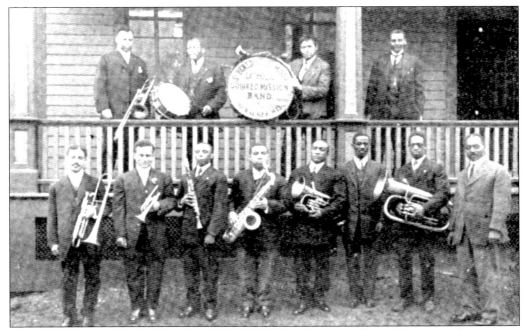

The men of St. Benedict the Moor Catholic Colored Mission Band get ready to march sometime during 1911. Capt. Lincoln C. Valle, standing on right side of the porch, beams with pride for his band. (Photograph courtesy of the Archives of the Archdiocese of Milwaukee.)

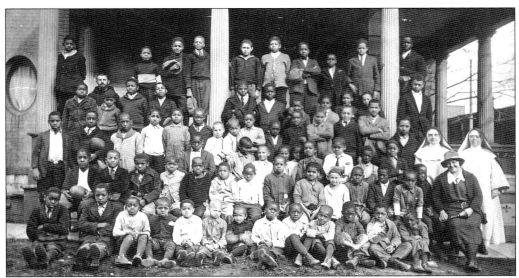

The guys line up for a photograph after a day of school and playing outside. The two Dominican sisters keep a stern eye on the proceedings while Fr. Phillip Steffes supervises from the rear. A teacher mutes the hand bell that will call the students back to their studies. (Photograph courtesy of the Archives of the Archdiocese of Milwaukee.)

The tables are set for a lunch in the dining hall at St. Benedict the Moor boarding school sometime in 1913. The day students walked home and back for lunch between the morning and afternoon school sessions. Chuck Holton remembers the walk. "We walked a mile to school in the morning, came home for lunch, went back to school and walked home after school. We walked four miles a day." (Photograph courtesy of St. Benedict the Mcor Church.)

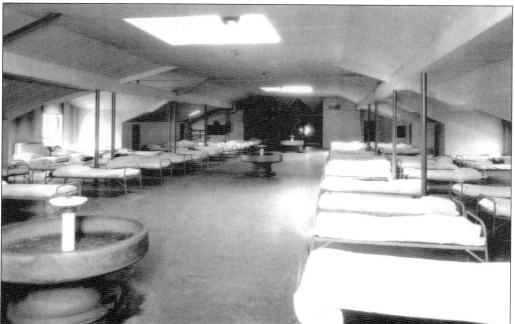

The beds are made with military precision in the dormitory for little boys and girls, which was located on the third floor of the convent in 1923. The older boys and girls slept in separate dormitories. (Photograph courtesy of St. Benedict the Moor Church.)

"ORDER LEADS TO GOD"

RULES AND REGULATIONS
OF
St. Benedict the Moor Boarding, Day School and Nursery
FOR
COLORED CHILDREN

311 - 315 NINTH STREET, **MILWAUKEE, WIS.** *1917*

Children of any denomination are accepted, provided they can be recommended by a [respon]sible person and are willing to conform to the rules of the Institution.

[W]hile all who can, must attend religious instruction, because without it moral training and [true] education is impossible, yet only such are permitted to embrace the true faith, who desire [it] and who have the consent of their parents or guardians.

Children are graduated for the High School, and are taught in industrial work in a [practi]cal manner.

The day school is free, parents, however, who can, are expected to pay for their children's [tuition] or rent a sitting in church.

Boarders pay $10.00 monthly for board, tuition, washing and the use of school and [librar]y books. Two dollars in addition a month pays also for clothing or music lessons.

Pupils who wish to stay at the Institution during the summer vacation pay $9.00 a [month]. Special concessions are made for poor children upon application. The Institution helps [poor] parents by supplying ordinary clothing free.

All mail coming in or going out is subject to inspection of the Rev. Superiors.

Children are not allowed to keep spending money, unless it be deposited with the Rev. Superior, who gives it according to her own discretion.

Children are not allowed to wear jewelry; if they have such, it is deposited with the Rev. Superior.

Children should have two pairs of shoes and a suitable amount of clothing to observe [clean]iness and proper decorum.

[1]0. Children may write home every month; but parents should provide the same with [pen]s and writing paper.

REGULATIONS FOR VISITING.

Parents, guardians, patrons and friends are welcome to examine or witness school work [in the] afternoon of the first Friday of every month.

Parents, guardians and friends may visit the children on any Sunday from 2 to 5 p. m.

Boarders may visit their parents, guardians or relatives, upon petition of the latter once [a mon]th on any Sunday from 10:30 a. m. to 2:30 p. m. Any child failing to comply with this [regula]tion, without a written excuse, forfeits the privilege of visiting.

Gifts in the line of provisions, made in large quantities are shared by all the children.

ADMONITIONS.

[H]ome visits are detrimental to children, unless parents keep close watch over them. Nickle [shows] and theaters according to the best authorities should be visited if at all very seldom...

The priests and the nuns kept a tight control on the environment for the boarders, inspecting their mail and allowing parents to visit only on Sunday afternoons. During home visits, which were permitted only once per month, parents were admonished to keep a close eye on their children and keep them out of the theaters. (Photograph courtesy of St. Benedict the Moor Church.)

Fr. Stephen Eckert emigrated from Ontario, Canada, in 1869 and became a U.S. citizen in 1897. He was appointed pastor of St. Benedict the Moor mission in 1913. During the period that he was pastor, he established a grade school and boarding school, started fund-raising for a new high school, and broke ground for the new church. (Photograph courtesy of St. Benedict the Moor Church.)

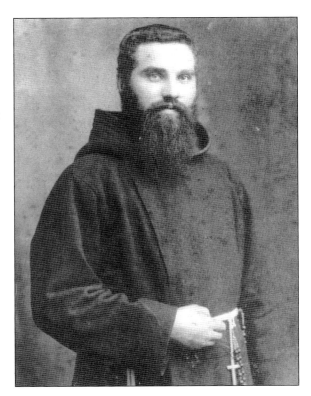

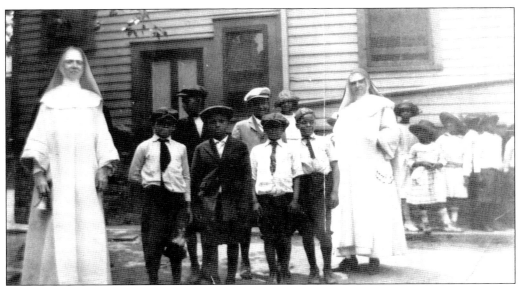

One of the Sisters of Notre Dame is ringing the recess bell as the boys and girls line up to return to class in 1923. The school dress code required hats, ties, and knickers for the boys, and straw hats and dresses for the girls. (Photograph courtesy of St. Benedict the Moor Church.)

The Girls' Residence on State Street has an impressive tower, a good place for a girl to pretend to be a princess. This undated photograph was probably taken in the early 1930s. (Photograph courtesy of St. Benedict the Moor Church.)

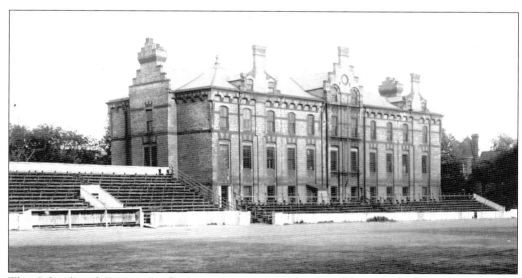

The School and Dormitory for Large Boys overlooks the athletic field, where many highly competitive baseball and football games between classmates were held. The building was razed in the mid-1960s, and the boys' school was moved to Marquette High School. (Photograph courtesy of the Archives of the Archdiocese of Milwaukee.)

This is an aerial photograph of St. Benedict the Moor Mission taken in 1934. The School and Dormitory for Large Boys is the large, four-story building on the left, on the far side of Tenth Street. The church (called a chapel in 1924), located on State Street, is in the center of the photograph. To the left of the church is the rectory, and behind it is St. Anthony's Hospital. To the right of the church, behind the billboard, is the Girls' Residence. Behind the large Girls' Residence are smaller buildings that are the Dormitories for Small Boys and Girls. (Photograph courtesy of St. Benedict the Moor Church and the Archives of the Archdiocese of Milwaukee.)

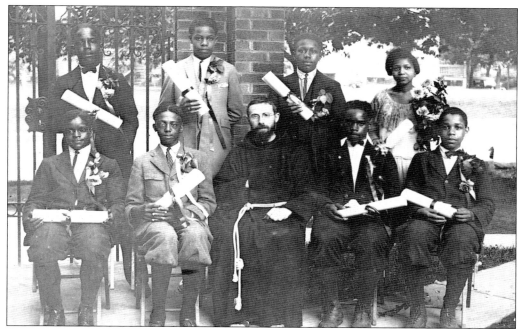

Seven young men and one young woman, members of an early St. Ben's graduating class, proudly show off their diplomas. Fr. Phillip Steffes sits in the middle of the group. (Photograph courtesy of the Archives of the Archdiocese of Milwaukee.)

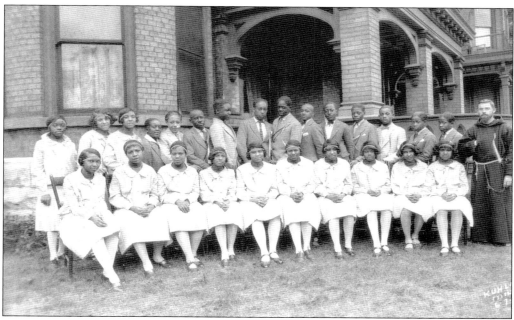

Young men and women, dressed in double-breasted suits and white dresses respectively, pose with Fr. Phillip Steffes on the lawn in front of the St. Ben's Girl's Residence in 1926. (Photograph courtesy of St. Benedict the Moor Church.)

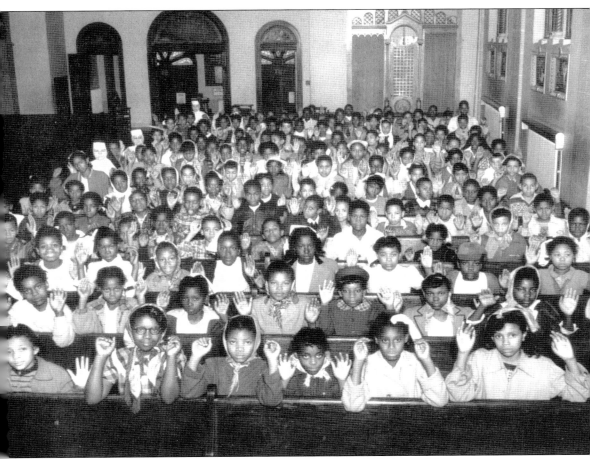

The students of St. Benedict the Moor hold their hands up to pray for people's special intentions. The idea was to "storm heaven" nine times with petitions, and contributions were gratefully accepted for these "Storm Novenas." The children are seated by grade, with the Notre Dame sisters holding down the strategic positions at the ends of the pews. (Photograph courtesy of St. Benedict the Moor Church.)

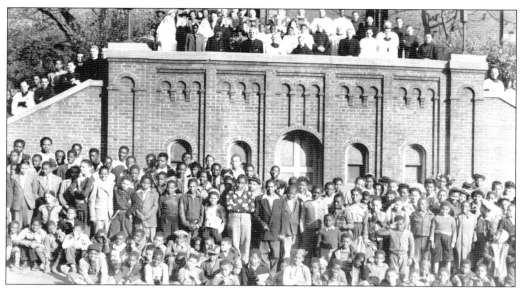

The St. Benedict the Moor Mission student body, priests, sisters, and teachers line up in front of the church on October 18, 1944. About 300 children attended the school during the 1940s, about half of them borders, and the school had a waiting list of more than 4,000 candidates from across the United States. (Photograph courtesy of House of Peace.)

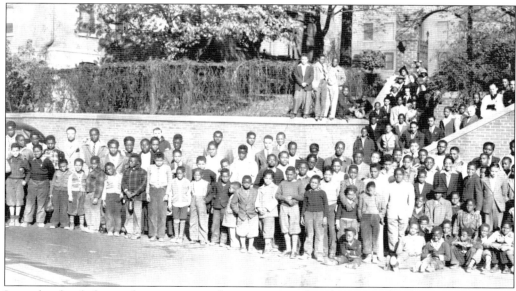

In grade school, the emphasis was on reading, writing, and arithmetic, with a lot of memorization, while in high school, fine arts, public speaking, and dramatics were added to the curriculum. Prominent black leaders were brought to the school to speak and act as role models to the students. The school set aside the month of February to lift up their heroes from the past, a precursor of Black History Month. (Photograph courtesy of the House of Peace.)

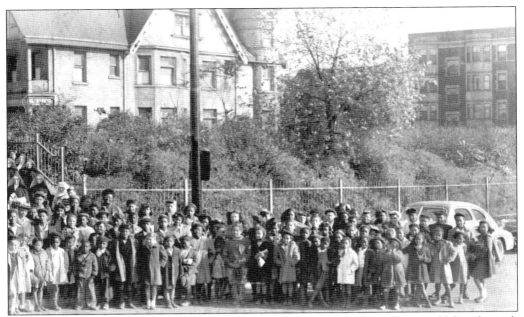

Attendance at regularly scheduled study halls was mandatory. Discipline could be physical; "Sister Marie downed (a student) and gave him an object lesson which (he) would not soon forget," Steven Avella relates in his history of the school. Students caught escaping to visit the forbidden fruits of the movie theaters downtown could be given "a good flogging." (Photograph courtesy of the House of Peace.)

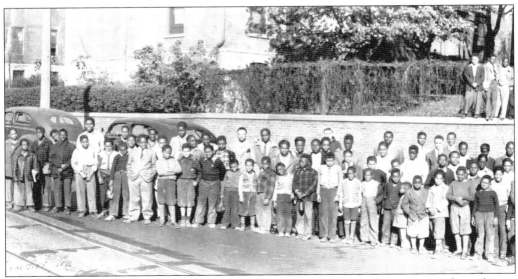

Doris Wood graduated from the St. Benedict the Moor Mission at 16, two years early, and went on to college. "I have good, fond memories of the nuns," she says. "I bought everything the nuns were selling, and still do today. The nuns gave us a sense of self conficence, that we could do anything that anyone else could do." (Photograph courtesy of the House of Peace.)

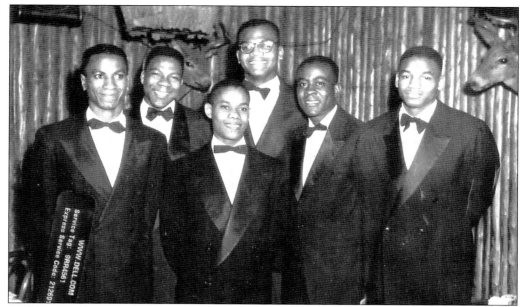

Archie Savage (front row, second from left) and his college fraternity got together at the Booker T. Washington YMCA in 1949. Dr. Archie Savage now serves on the national YMCA board of directors. Savage received his degree in University Administration and Communication, and was a special agent for the U.S. Government Intelligence Service for 22 years. (Photograph courtesy of Mary Mitchell [née Savage].)

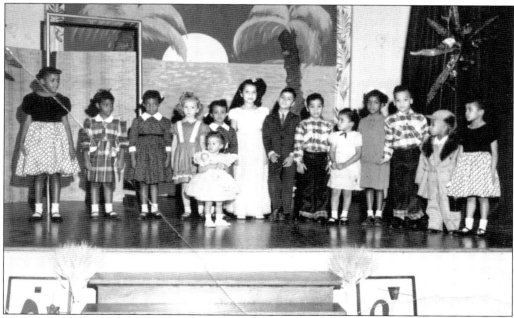

This Sunday school pageant at St. Mark's African Methodist Episcopal Church in 1953 seems to be timeless. One can imagine the parents in the audience proudly darting up to take a quick photograph. The two children with checked shirts and high-cuffed jeans, standing on the right of the group, look like twins. (Photograph courtesy of Carolyn Callier-Malone.)

Four

ENTERTAINMENT
MINE EYES HAVE SEEN THE GLORY

Because they were not allowed in the white clubs and hotels, African Americans created their own vibrant entertainment district in Milwaukee. When white patrons were attracted to the jazz and blues offered by the black clubs, the Bronzeville entertainment district became one of the few points of racial integration in Milwaukee in the first half of the 20th century.

The Metropole was the first Bronzeville club to attain popularity in the late 1920s, and the Flame and Moon Glow were two that lasted the longest. Other clubs included the Blue Room, Chateau, Celebrity Club, Gold Coast Tavern, Intrigue, Milwaukee Club, Mr. Jimmy's Place, Morri's, Pelican Club, Polk A Dot, Ranchos, Savoy, 711 Club, T Joes, Thelma's Back Door, Trocadero, and the White House.

Those who could not afford the $7 price of a set-up could still get an evening's entertainment by nursing a drink like milk on the rocks. Dancers were paid $1 and orchestra members $3 to work an entire evening. Tuesday night was Celebrity Night at the clubs, and entertainers were invited onstage for a short performance as special guests.

Policy games, an illegal form of gambling that funded the amusement companies, flourished. In 1948, the *Milwaukee Journal* estimated there were 11 wheels generating $1 million in annual revenues. Dream books like *Aunt Sally's Policy Players Dreambook*, *The Three Witches*, and *Combination Dream Dictionary* were originally published to interpret dreams, but later used for picking numbers.

As Dixieland jazz and blues music began to attract a following, black bands traveled the "Chitlin Circuit," throughout the Midwest, and even as far west as Seattle. The band members and their wives traveled together by bus, sleeping in the seats, since hotels would not rent them rooms. Although the clubs they played were called "Black and Tan" clubs, the audiences were mostly white. Alma Eggert, who traveled with her husband, the leader of the Hal Robbin Band, recalls a gig in North Dakota where the band was forced to play all night by a group of gun-wielding white patrons.

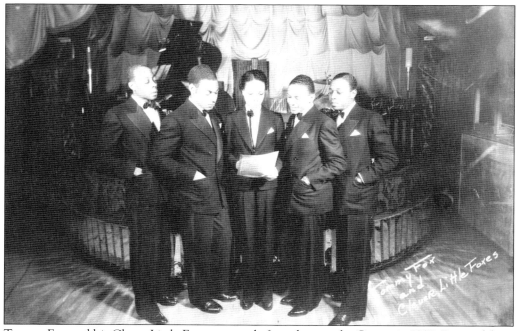

Tommy Fox and his Clever Little Foxes get ready for a show at the Congo in 1929. Pictured from left to right are unidentified, Tommy Fox, Loretta Whyte, and Fox's children, the "little foxes." (Photograph courtesy of Aaronetta Anderson.)

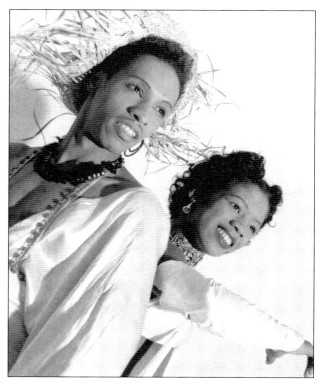

Cricket and Satin Doll were specialty dancers who sang and danced at the Flame in the 1940s. The inscription on the back of the photograph reads, "To the sweetest Sis a girl could ever have. Stay as sweet as you are now. And keep up the good work in dancing. Love you madly. Love always, Satin Doll and the Cutter. Lots of Luck with Daddy! (Smile)." (Photograph courtesy of Mary Young.)

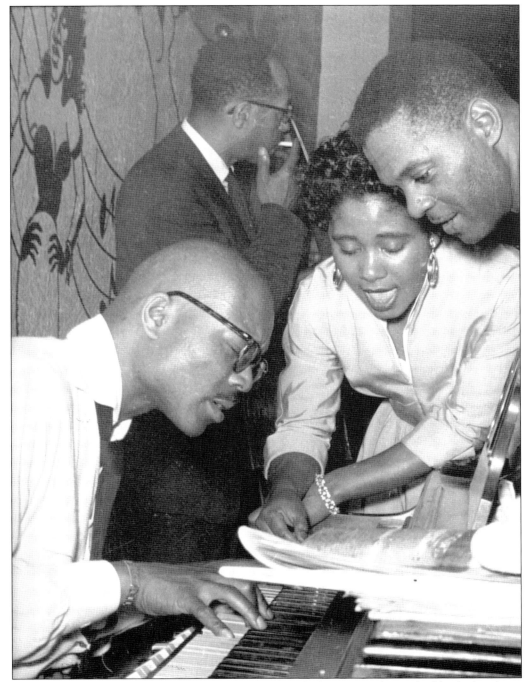
Nellie Wilson (center), one of Bronzeville's most popular hostesses who worked both the Flame and the Moon Glow, scats with the ivories in 1950 at the Polk A Dot. (Photograph courtesy of Aaronetta Anderson.)

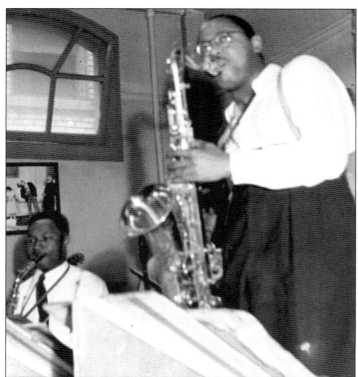

J. D. King, one of the saxophone players in the Bernie Young Band, takes a solo. (Photograph courtesy of Mary Young.)

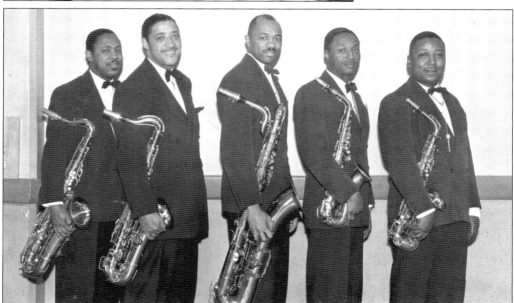

The Bernie Young Band saxophone section is pictured in 1941 with, from left to right, J. D. King, Leonard Gay, Clarence Medford, Eugene Branshaw, and Jimmy Nubly. Gay was famous for playing perfect solos on his alto saxophone. A few years later, Gay started his own band, for which he arranged most of the music the group performed in addition to performing his alto saxophone solos. (Photograph courtesy of Mary Young.)

Skeeter Evans hits a high note while playing a solo with the Bernie Young Band. (Photograph courtesy of Mary Young.)

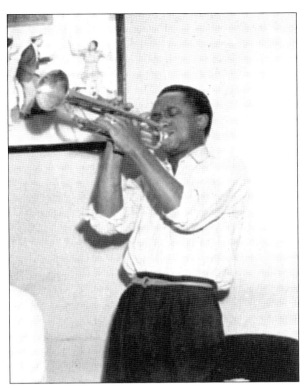

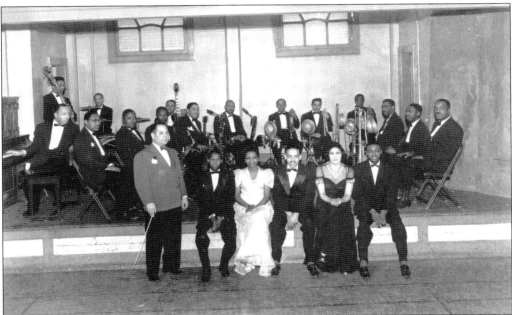

The Bernie Young Band is set up to play for a big dance at the Urban League gymnasium in 1941. The names listed on the back of this photograph are Leo Schultz, Eugene Brashan, George Left, Skeeter Squese, Jimmie Dudley, Leonard Gay, Clarence Bedford, Sam Moore, Richard Heard, Pate, P. G., and Polly. (Photograph courtesy of Mary Young.)

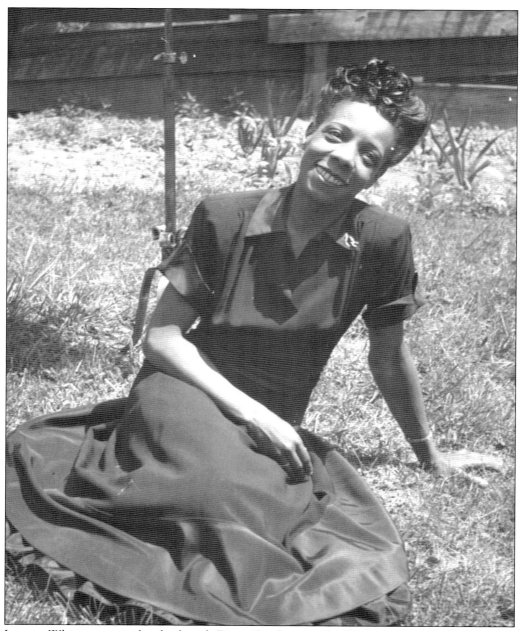
Loretta Whyte poses in her backyard. Diane Sanders recalls, "She was a tiny little thing but could make a big sound with the organ." And Eddie Jackson believes Whyte had "a big, beautiful voice. . . . the best voice in this city." (Photograph courtesy of Aaronetta Anderson.)

Loretta Whyte performs at her Steinway in the late 1930s. She played the blues, a jazzy type blues, according to Frank Gay. "She could sing anything but blues were her number," recalls Eddie Jackson. She was noted for her ability to play both the piano and organ well while singing. (Photograph courtesy of Aaronetta Anderson.)

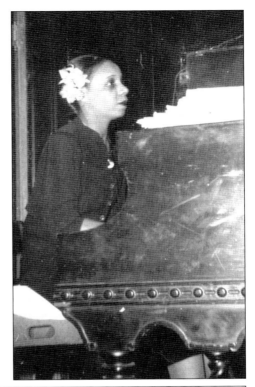

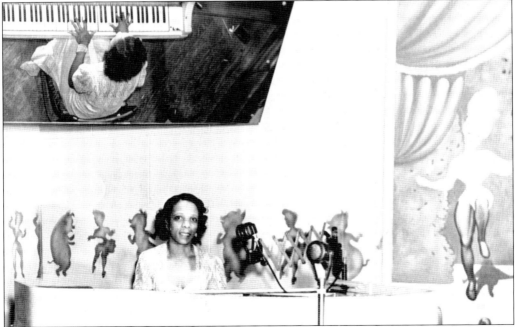

Loretta Whyte had a five-piece band to back her up at the Flame: George Lott on the trumpet, Buster Washington on the Alto Sax, Bobby Burdette on the tenor sax, Paul Bryant on the tenor sax, and T. G. Washam on the drums. (Photograph courtesy of Aaronetta Anderson.)

Mary Young (left) and Pearl Rozelle relax in the Flame dressing room in 1941. (Photograph courtesy of Mary Young.)

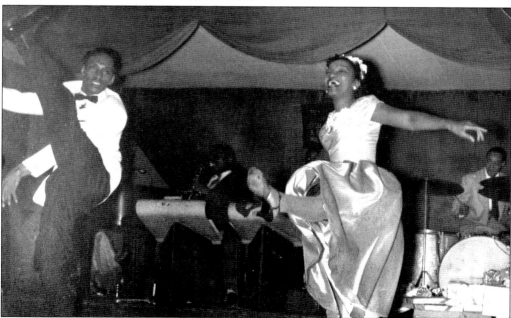

Tuesday night was Celebrity Night at the Flame, where special guests in the audience were "called up" to perform. Here Mary Young is dancing with Cricket. Although Cricket and Young did not normally dance together, she recalls, "He knew the steps." Monday night was Celebrity Night at the Moon Glow, and the two clubs would trade off. (Photograph courtesy of Mary Young.)

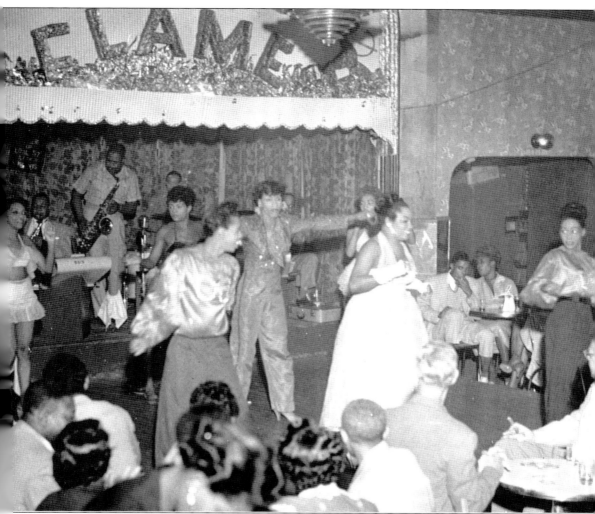

The evening show wraps up with the finale at the Flame in the early 1950s. Mary Young is the woman in the white dance costume on the left of the photograph in the rear. Cricket is the lead dancer on the left, in the front. (Photograph courtesy of Mary Young.)

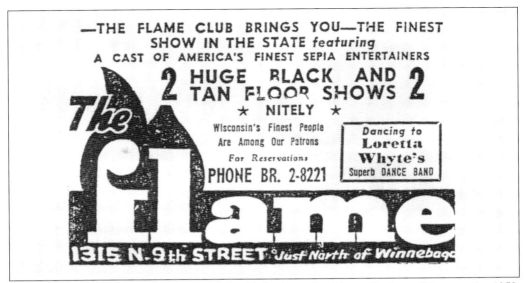

This advertisement for the Flame was published in the *Negro Business Directory* in 1953. The Flame was owned by Derby Thomas and Loretta Whyte. (Advertisement courtesy of Sylvester Sims.)

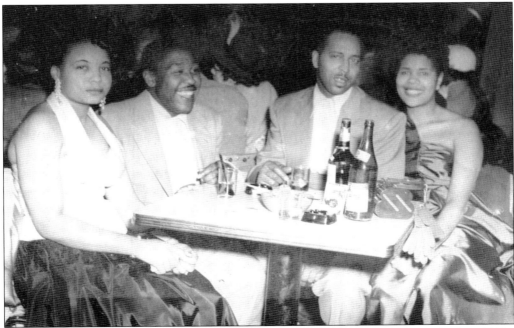

Virginia McKinney (right) parties at the Flame with her girlfriend Maxine in the late 1940s. (Photograph courtesy of Virginia McKinney.)

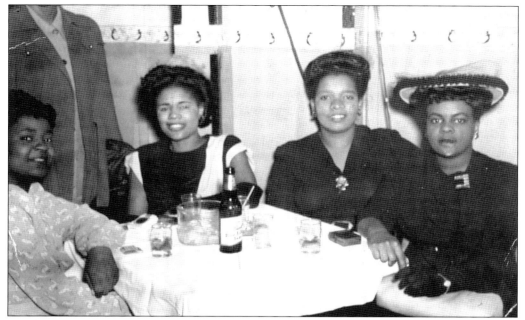

The ladies are celebrating at the Moon Glow on a Saturday night in 1945. Seated from left to right are unidentified, Virginia McKinney, Jo Anna Schultz, and Mary Cary. (Photograph courtesy of Virginia McKinney.)

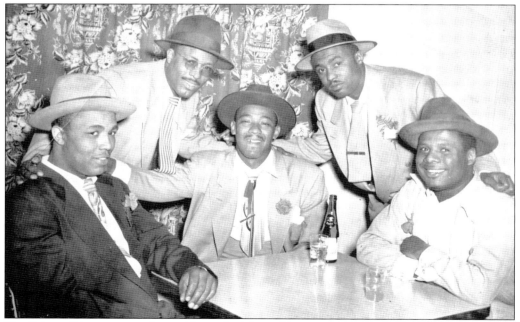

The "players" hang out at their table in the Moon Glow sometime in the early 1950s. Saturday night was "Walnut Night," a time when the guys would get dressed up to impress the girls. (Photograph courtesy of Virginia McKinney.)

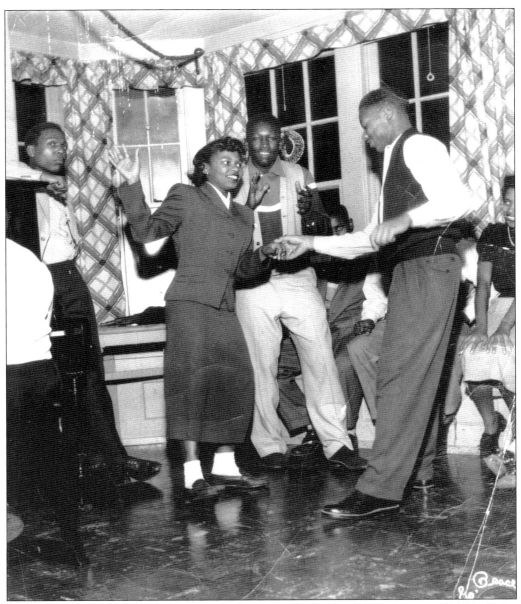
Rossetta Foote (née Savage) dances with friends at the Booker T. Washington YMCA. Zohn Savage is peeking through from the back. Foote was an elementary schoolteacher for Milwaukee Public Schools and later became an assistant administrator for the school system. (Photograph courtesy of Mary Mitchell [née Savage].)

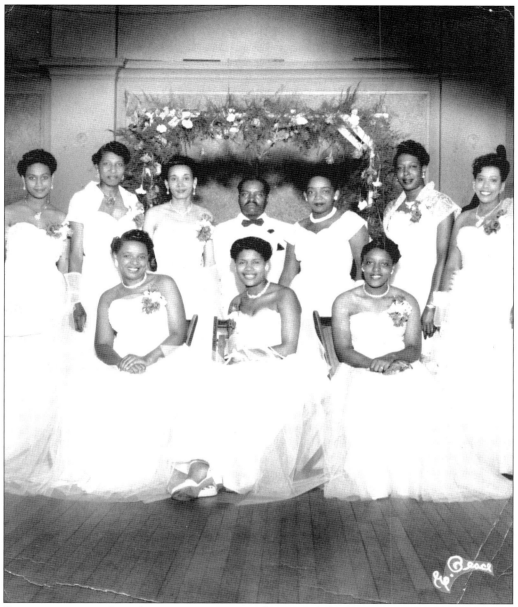

Some matinees, such as this one, were organized to provide high-class entertainment, and the dress code was formal. The Flame was the most popular place for social clubs to hold matinees; entertainment might be one of the top local groups or even a national headliner. From left to right are (first row) Suless ?, Virginia McKinney, and Magnolia Knox; (second row) Constance "Toots" Good, unidentified, Bernice Smallwood, Huey ?, Delores ?, Juanita Smith, and Virginia Lee. Smith is Howard Fuller's mother. (Photograph courtesy of Virginia McKinney.)

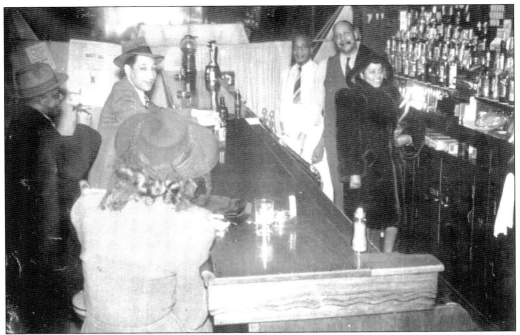

Aaronetta Anderson's mother, Myra Evans Galloway (in the fur coat), stands behind the bar at the Blue Room, located at 821 West Walnut Street in 1939. Myra and Aaron Evans had recently married when this photograph was taken. (Photograph courtesy of Aaronetta Anderson.)

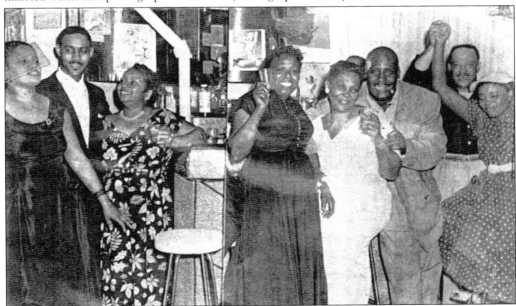

The party continues at the Casablanca, a well-known after-hours place run by Evan Hill. Headliner musicians would get a second wind after finishing up at places like the Flame or the Moon Glow, and perform until morning at the Casablanca or Art's, another famous after-hours place. The Casablanca was a rooming house in an old converted mansion at 1641 North Fourth Street that catered to black musicians. (Photograph courtesy of Sylvester Sims.)

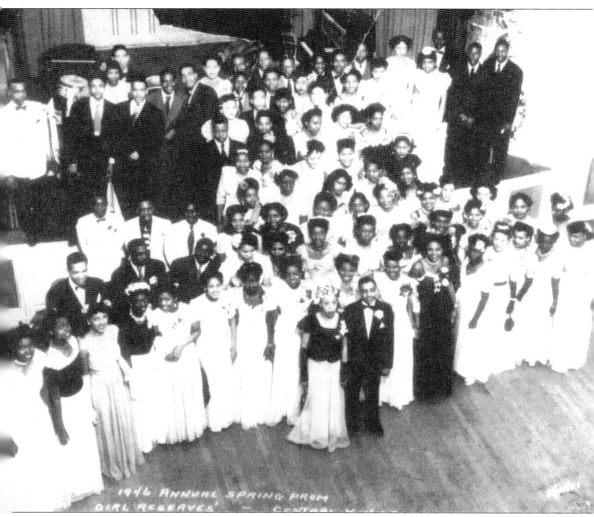

Formal dances were held at both the Booker T. Washington YMCA and the YWCA. Here high school students line up for a group picture at the spring dance at the YWCA in 1946. (Photograph courtesy of Sally Jackson.)

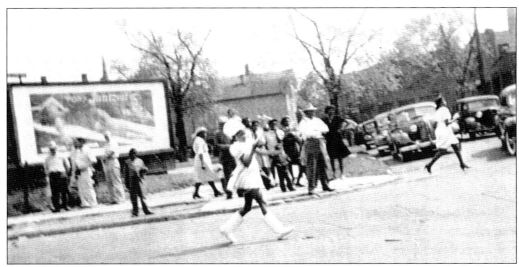

Ozzie Evans is the drum majorette for the drum and bugle corps, led by A. C. Carrington, as it marches by at the corner of Ninth and Galena Streets. The Elks sponsored an annual parade through the neighborhood, with the parade first going west on Walnut Street, then north on Ninth Street and east on Galena Street. (Photograph courtesy of Aaronetta Anderson.)

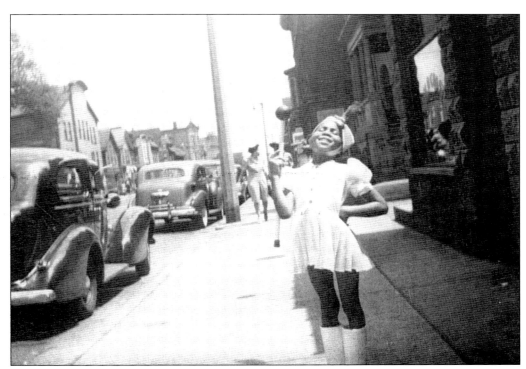

Ozzie Evans practices twirling her baton in 1945 in front of the Apex Cab Company on Walnut Street. Kathy Kirk was the leader of the baton corps. (Photograph courtesy of Aaronetta Anderson.)

Five

SPORTS
GUIDE MY FEET

Sports activity in Bronzeville occurred within the boundaries of centers such as the Lapham Park Social Center, Booker T. Washington YMCA, and the Urban League. No matter what the sport, segregation made it almost impossible for young black athletes to get into the kind of colleges where they could get the training required to gain wider fame. One exception was Sylvester Sims, who went on to become the first African American to win the Wisconsin Amatuer Athletic Union State Diving Championship; he learned to dive in the Lapham Park Pool, which was nicknamed "The Ink Well."

Boxing was the first sport to cross the color line. Baby Joe Gans, former lightweight champion of the world, was a hero in the Bronzeville community who trained many young boxers at the Urban League. Famous boxers who trained in Gans's gym include Jimmy Sherrer, a champion boxer from 1945 through 1949; Doll Raferty; "Bubby" Pitts, an NCAA Wisconsin champion; Al Moreland, a professional trainer; and Dick Bartman, the only white boxer who trained in Bronzeville and who continues to referee boxing matches today. Bob Harris recalls that in army boxing matches, "The first three nights, all the black soldiers beat each other up, then the last two nights the winners fought the whites for the championship."

Ethel Brunner (née Clifford), the first African American to be hired full time at the Lapham Park Social Center, was a hero and mentor to the girls in Bronzeville. Besides teaching them skills like modeling, dancing, and exercising, Brunner initiated a program to teach young girls baseball. Aaronetta Anderson was one of her protégés, and Anderson's team won two citywide championships in the playground league before she moved on at the age of 12 to play on the High Step Tavern women's team. Anderson recalls, "the older teenage girls were more interested in 'stylin' but I loved the game and played to win." Playing for the Kaiser Shoes team in the Open League, her team won the city championship. Anderson was inducted into the Old Time Ball Player Hall of Fame and is a member of that organization's board.

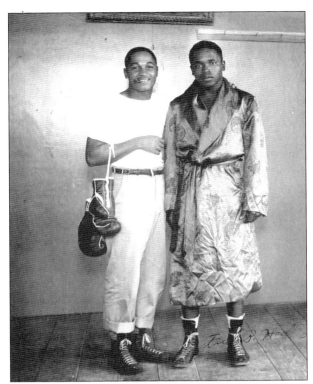

Fred Hadley (right) was a member of the U.S. Army of Occupation Japan Boxing Team. The photograph was taken in Korea in 1946. The boxing team was integrated, although the U.S. Army was segregated. Everyone was allowed to compete, and the best men were put on the boxing team. Bob Harris says there were some tensions between the guys on the team, but they worked it out and became friends. (Photograph courtesy of Bob Harris.)

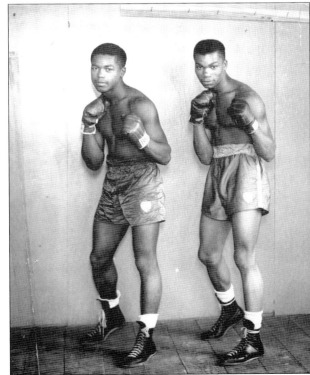

Fred Hadley (left) and Bob Harris take a break from training in Ascom City, Korea, to pose for the camera. The two men trained for a month to prepare for a match with professional Korean boxers held in July 1946. (Photograph courtesy of Bob Harris.)

Bob Harris (second from right) shows off the diamond-studded watch he won for beating the Korean Welter Weight Champion in two rounds before 35,000 people on July 4, 1946. Someone in the crowd won $80,000 on Harris's victory. After the fight, Harris was assigned his own jeep and a house, complete with a houseboy. The boxer on the left is Fred Hadley, Harris's sparring partner. (Photograph courtesy of Bob Harris.)

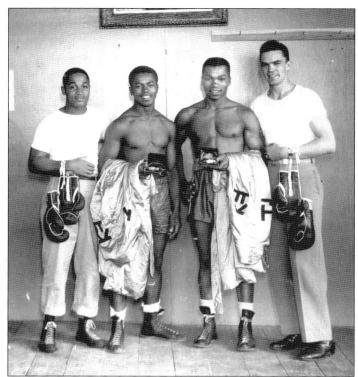

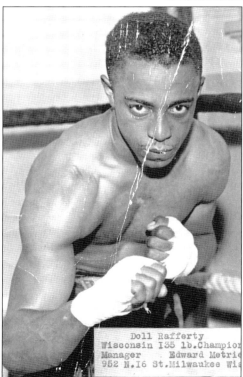

Doll Raferty, one of "Baby" Joe Gans's pupils, won a Golden Glove Championship. He then went professional, fighting world champion Willie Pip. Baby Joe Gans, the popular trainer at the Urban League located at Ninth Street and Vine Street, was the former lightweight champion of the world. (Photograph courtesy of Virginia McKinney.)

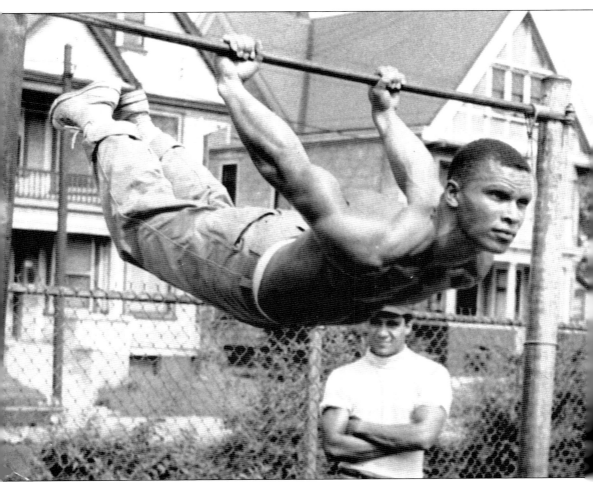

Sylvester Sims works out on the horizontal bar as part of his training. Sims had crossed eyes as a child and at age 11 went into Children's Hospital for surgery, which, unfortunately, was not successful. He got a lot of teasing at school because of his eyes, which may be why he was interested in boxing and "prayed to the Blessed Virgin Mary every day" to have his eyes straightened. At age 17, in a boxing match with "a fighter named George from Green Bay," Sims feinted and George threw a jab that hit Sims "smack between the eyes and square on the nose." After winning the match on a technical knockout, Sims went into the locker room to see if his nose was broken and found that his eyes were straightened. Big Bunky Green is the person behind Sims. (Photograph courtesy of Sylvester Sims.)

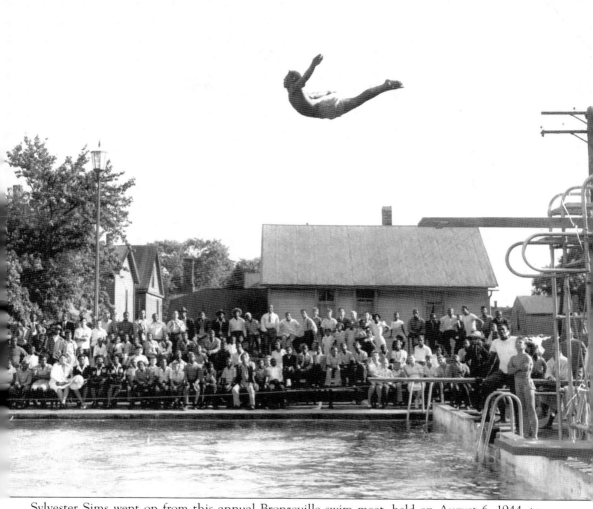

Sylvester Sims went on from this annual Bronzeville swim meet, held on August 6, 1944, to become the first African American to win the Amateur Athletic Union State of Wisconsin Diving Meet. The Bronzeville Swim Meet was an event that the whole community turned out for. William Mosley is on the right, standing in his swim trunks, and Carl Gee is on the far left of the front row, the last one on the end. (Photograph courtesy of Sylvester Sims and Milwaukee Journal Sentinel.)

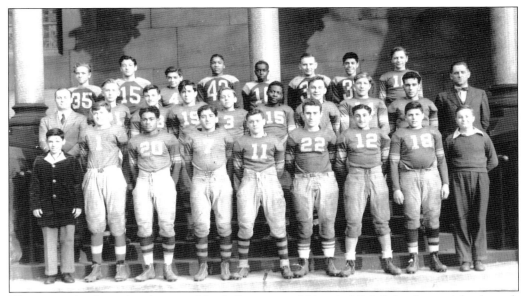

The geographic boundary between North Division and Lincoln High Schools ran right through the middle of Bronzeville, so most Bronzeville students went to one of these two Milwaukee Public Schools. Here the Lincoln High School football team poses for a team picture in 1943. (Photograph courtesy of Bob Harris.)

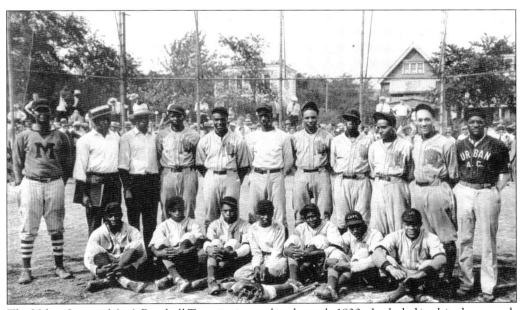

The Urban League Men's Baseball Team is pictured in the early 1930s. Included in this photograph are Joe Trotter, William V. Kelley, Harvey Sititch, Slag Johnson, Nasly Reinhart, Leon Thomas, Osber Sampson, Art Wilson, James Hendricks, Jimmy Fields, Neut Walters, Norris Adkins, Wesley Harrison, and Henry Moore. (Photograph courtesy of Aaronetta Anderson.)

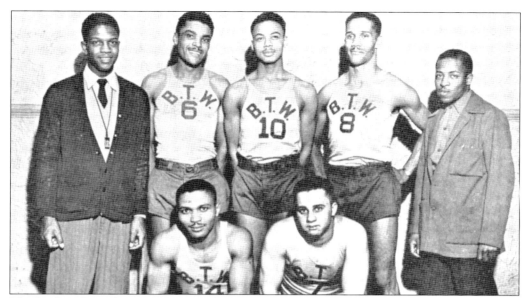

The Booker T. Washington Men's Basketball Team played teams from the downtown and other YMCAs in Milwaukee and traveled to Evanston, Illinois, and Beloit, Wisconsin, to play the black teams from their YMCAs. "That's the way it was!" says Ralph Jefferson. From left to right are (first row) Richard Bower (No. 14) and Ted Washington; (second row) Ralph Jefferson (in the cardigan sweater), unidentified (No. 6), James Knight (No. 10), Lenwood Rayford (No. 8), and Arthur Bacon (wearing jacket). (Photograph courtesy of Sally Jackson.)

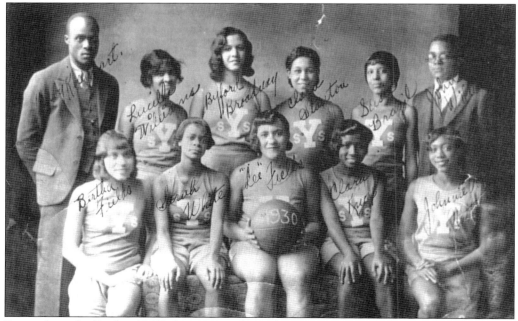

Pictured on the Booker T. Washington Girl's Basketball Team in 1930, from left to right, are (front row) Bertha Fields, Sarah White, "Lee" Fields (holding ball), Clara Kries, and Johnnie North; (second row) Kirby Klingart (coach), Lucille Williams, Byford Broadway, Clara Stanton, Susie Brazil, and John Wilkes. (Photograph courtesy of Aaronetta Anderson.)

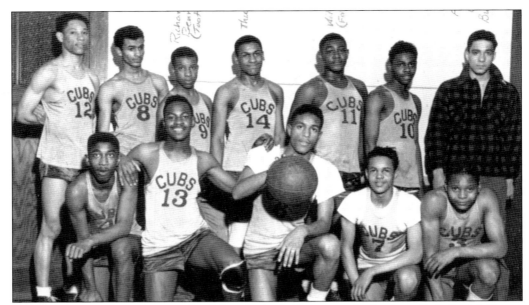

The boys line up for a photograph of their basketball team in the Lapham Park Social Center gymnasium. From left to right are (front row) Edward "Tish" Fawsom (No. 4), Earl Williams (No. 13), Thomas Grider (with ball), Jones (No. 7) and Bugs Holt (No. 3), unidentified (No. 12), Bruce Richardson (No. 8), Richard "Tootie" Bennett (No. 9), Thurman Hawkins (No. 14), William "Fat" Boyers (No. 11), Gene Moore (No. 10), and Francis "Big Bunky" Green (in plaid shirt). (Photograph courtesy of Larry Miller.)

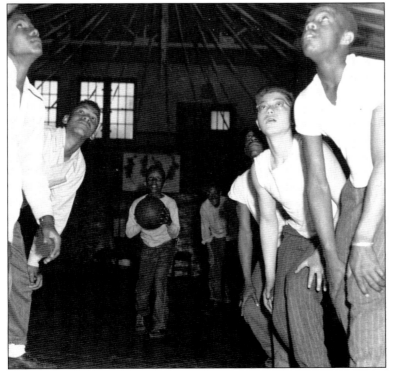

The boys, still wearing their school clothes, are poised to gather in the missed free throw at an after school makeup game in the Lapham Park Social Center gymnasium. This photograph was taken in 1941. (Photograph courtesy of Larry Miller.)

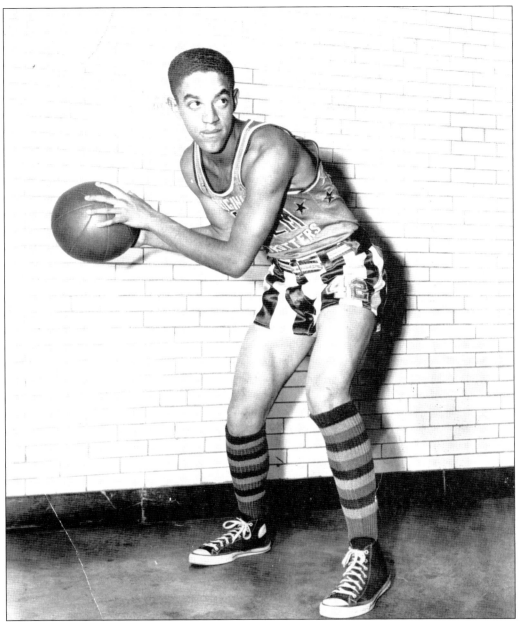

Chuck Holton played forward for the Harlem Globetrotters in the early 1950s. Holton went to St. Norbert's College in De Pere, Wisconsin, where he was spotted by a scout and invited by the team owner to try out for the Globetrotters. Holton earned a spot on the team and played for the Harlem Globetrotters for six years. Holton fondly remembers playing on the Globetrotters with Marques Haynes, the "World's Greatest Dribbler." Holton's mother grew up in Sands Spring, Oklahoma, which was also Haynes's hometown. The Globetrotters still stay in touch, and celebrated their 75th reunion 2002. (Photograph courtesy of Chuck Holton.)

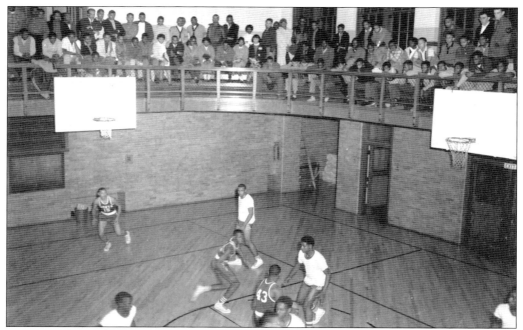

Parents and friends watch from the second-floor balcony as the white T-shirt team competes against the jerseys team in a basketball game at the Lapham Park Social Center gymnasium. (Photograph courtesy of Larry Miller.)

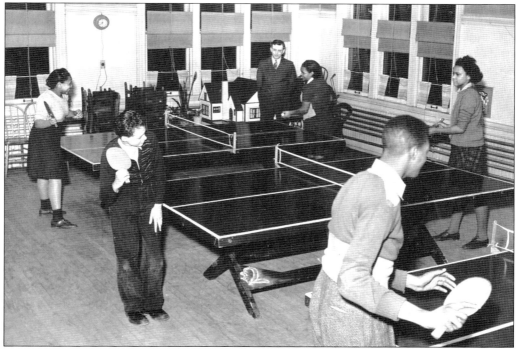

The timeless sport of Ping-Pong was as popular in 1941 at the Lapham Park Social Center as it is today. (Photograph courtesy of Larry Miller.)

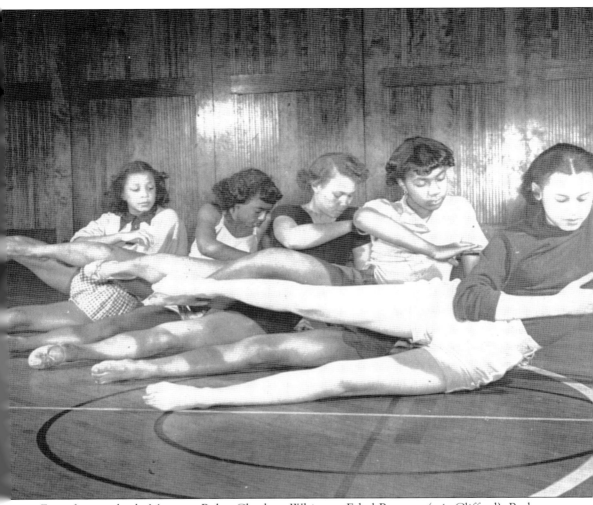

From front to back, Margaret Bobo, Charlene Whitmor, Ethel Brunner (née Clifford), Barbara Howze (née Sanders), and Barbara Cabill exercise in the gymnasium at the Lapham Park Social Center in 1941. Brunner was the first African American to be hired as a full-time employee, and developed an extensive after school program of modeling, dancing, exercising, and sports for young girls. (Photograph courtesy of Larry Miller.)

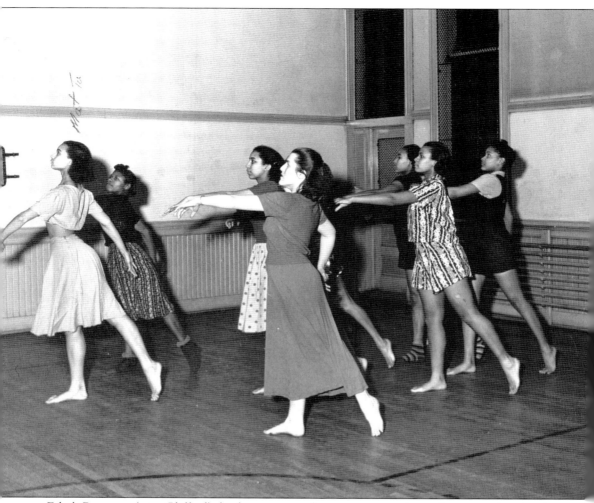

Ethel Brunner (née Clifford) leads a group of young women in a dance routine in the gymnasium at Lapham Park Social Center, in February of 1941. Two of the young women dancing behind Brunner are Jane Mildred Carter (left) and Vi Turner. Brunner, the director of Lapham Park Social Center, taught home economics, etiquette, and crafts during the summer months. She acted as a role model and was devoted to the young people. (Photograph courtesy of Larry Miller.)

Six

FAMILY

SHALL WE GATHER AT THE RIVER?

The violence of slavery and Jim Crow was not far removed from the African Americans living in Milwaukee's Bronzeville. Calvin A. Reeves, a relative of Lenore Mathews, came to Milwaukee in 1863, traveling with a Union soldier. Around the age of eight, Reeves had escaped the harsh plantation life of the Deep South to join the Union Army as a water boy. Diane Sanders remembers a family gathering in the South when she was 12 and visiting with her great-grandmother who had been a six-year-old slave when emancipation came in 1865.

Priscilla Franklin relates that her father, Jackson A. Riley, when he was a young man, saw his cousin lynched in Texas and vowed never to return there, a vow he broke only to attend his sister's funeral. He sent his seven children to camps in northern Wisconsin in the summer rather than send them to visit their relatives in the South. Ethelel Sartin's father, Buffus McClain, said he would not leave his children in the South "because of the hangings."

Families helped each other out. Anna Lee Hollis was hired to take care of Jackson A. Riley's seven children in 1939, after he lost his wife. She was a wonderful surrogate mother, Sally Jackson (née Riley) recalls. "She taught us so much!" Later Hollis took in foster children until she was in her 70s and lived to be 110. Virginia McKinney's mother, Daisy Collins, took in three foster girls when their mother was ill with tuberculosis and, after their mother died, accepted them as family.

Institutions such as the Lapham Park Social Center and Booker T. Washington YMCA played a key supportive role in offering social activities, after school and evening classes, glee clubs, and field trips. Priscilla Franklin remembers that Lapham Park had both a boys' and a girls' playground, and that her family would gather in the evening to be with the kids as they played there. The green space that was used by the neighborhood for all kinds of activities was an important part of the community.

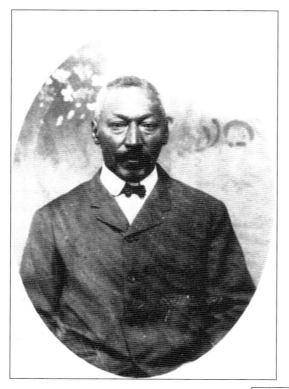

Calvin A. Reeves was born approximately in 1852, although the exact year is not known. Escaping from slavery in either Missouri or Mississippi, he was a water boy for the Union Army and followed a Union Soldier home to Milwaukee. He was between 10 and 12 years of age when he arrived in Milwaukee in 1863, two years before the Emancipation Proclamation. (Photograph courtesy of Lenore Mathews.)

Calvin A. Reeves, the first African American to live in Fox Point, worked on a farm called Mack and Sweitzer's that was located between Dean and Brown Deer Roads. Reeves worked many years for the Uihlein family, training and doctoring horses. He married Wilhelmina Schroeder, shown here, who was white; theirs was one of the first interracial marriages in Milwaukee. (Photograph courtesy of Lenore Mathews.)

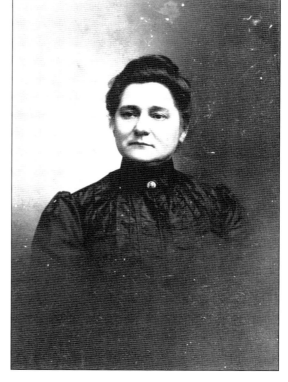

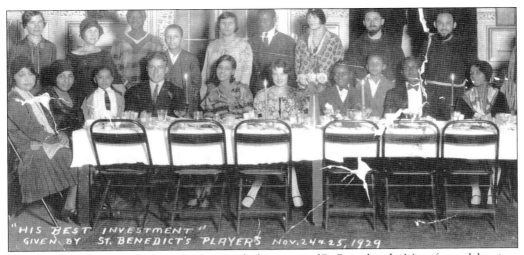

The Sims family gathers in November 1929 in the basement of St. Benedict the Moor for a celebration. Standing from left to right are ? Flynn, unidentified, Joavive Caldwell, Ward Sims, Agnes Sims (née Adolph), unidentified, Eppe Ball, Fr. Phillips Steffes, and Fr. Stanislaw Matchekosky. Ward Sims joined the Special Forces in 1939. (Photograph courtesy of Sylvester Sims.)

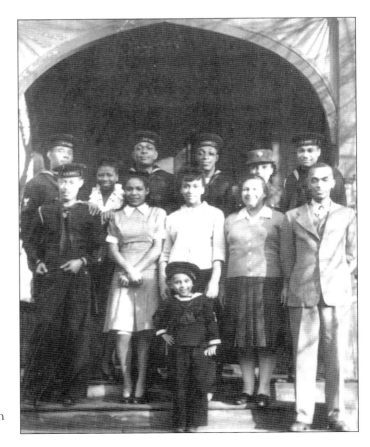

Navy friends from the USO join the Sims family for a social afternoon in 1943. Anna Maye Sims is the woman in the Woman's Army Corps uniform. Agnes and Granville Sims, mother and father of the Sims family, stand in the front row on the right of the photograph. Jack Sims is the young boy in the sailor's uniform. (Photograph courtesy of Sylvester Sims.)

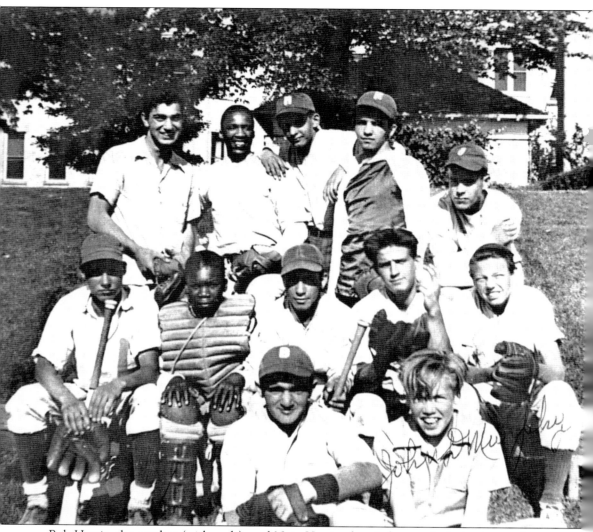

Bob Harris, the catcher (with pads), and Nate Harris, the pitcher, worked closely together on the Milwaukee County Children's Home baseball team. Their mother had Parkinson's disease, and their father suffered from a lung disease related to foundry work, so they could not take care of their family. Nate Harris became the Health and Social Services manager for governors Martin Schreiber, Lee Sherman Dreyfus, and Tommy Thompson. (Photograph courtesy of Bob Harris.)

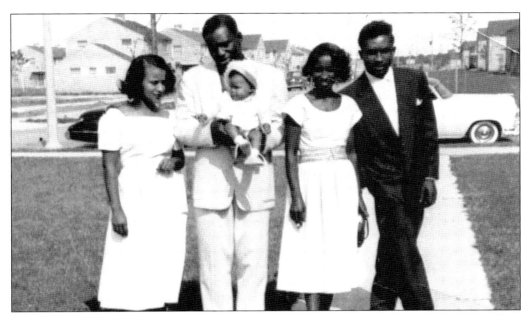

Edith Venable (left) and unidentified friends from Michigan came to see the sights in Milwaukee. At that time, Edith and her two children lived at Westlawn, a new housing development in Milwaukee. Her friends from out of town asked to go "in town" to see the sights. Edith and her friends went to Bronzeville to spend time with a friend and her mother. (Photograph courtesy of Edith Butts.)

Edith Venable (left) has a tender moment with her two children, Loretta, age seven, and Clifton, age six, at Westlawn in 1950. The Westlawn Housing Project added sorely needed housing for African Americans in Milwaukee. (Photograph courtesy of Edith Butts.)

Sisters Cora Bowers (left) and Anna Payne Cox pose before an outing, in 1930. Cora later helped her brother-in-law Londy Cox raise his three girls after Anna Cox died. (Photograph courtesy of Harriet Spicer [née Cox].)

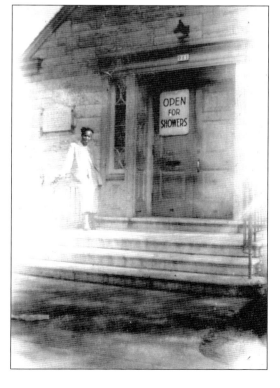

Irene Cox (left) poses by the Lapham Park pool, located directly across the street from their house on Brown Street. This swimming pool was built in 1941 by the Works Progress Administration at a cost of $250,000. Recreation facilities in Bronzeville were quite limited but heavily used. (Photograph courtesy of Harriet Spicer [née Cox].)

In 1930, the annual "All Churches" church picnic was held in Lake Park. Virginia McKinney, pictured here at age eight, remembers that the food was "great!" She enjoyed jumping rope and playing games like dodgeball and baseball. (Photograph courtesy of Virginia McKinney.)

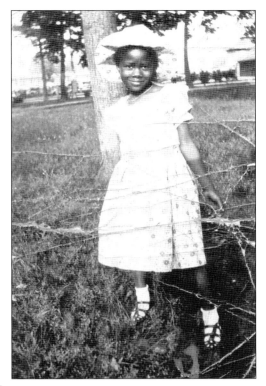

Virginia McKinney (right) says her mother, Daisy Collins, was "a wonderful woman!" The two are pictured in 1941, the year McKinney's daughter Dian was born. Collins helped raise her granddaughter, taking care of her while McKinney worked. The two women are standing at Tenth and Vine Streets. (Photograph courtesy of Virginia McKinney.)

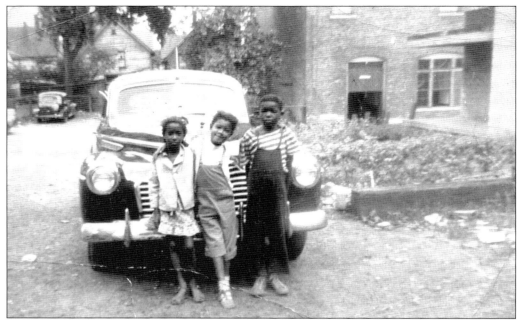

Dian Wyatt (left), Janet ?, and Cookie Williams are playing in the backyard on the 1700 block of Third Street. The backyard was an open grassless area, where people parked their cars. Recreation space for children was limited; Lapham Park was the place where people went if they wanted some green space. (Photograph courtesy of Virginia McKinney.)

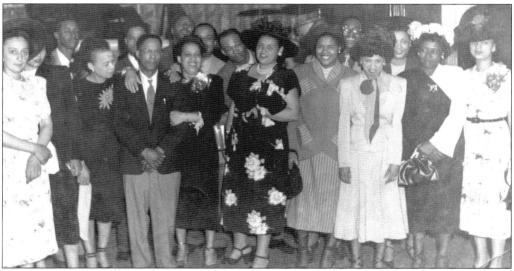

The Morgan Family organized a Father's Day Matinee at the Flame in 1948. The various social clubs sold tickets, with a prize being given out for the table that sold the most. Sunday matinees at the Flame were very successful, as there was always a good band, specialty and shake dancers, and a floor show. Virginia McKinney is the third woman from the right, in the two piece suit. (Photograph courtesy of Virginia McKinney.)

Woodrow Wilson (left) and Lester Wilson pose with their dress walking canes in 1917. Woodrow Wilson was born in 1885, migrating to Milwaukee in the early 1900s. He worked for Heil Company as a laborer, read the daily *Wall Street Journal*, and only bought his clothes in the fashionable stores located east of the Milwaukee River. (Photograph courtesy of Chuck Holton.)

Nace Holton (left) and John "Hack" Welch departed St. Louis for better jobs in Milwaukee around 1917. Welch was married to Holton's sister Etta. Both Hack and Etta worked in a packinghouse, in an area they called "the roundhouse." (Photograph courtesy of Doris Woods.)

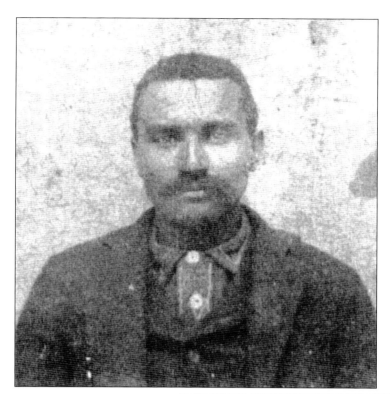

Frank Holton, age 25, worked for Greenbaum and then Albert Trostle Tannery in 1933. Starting work at 15, he often worked two or three jobs at the same time. He was the youngest of a family of nine children. (Photograph courtesy of Doris Woods.)

Mary Holton was the Holton family matriarch, shown here in 1933 sitting in her backyard on Tenth Street. A story handed down through the family says that when Mary Holton was approximately eight she saw her sister sold into slavery. The story goes that Mary Holton last saw her sister on the back of a wagon, calling, "Good bye" and "I love you!" (Photograph courtesy of Doris Woods.)

Fanny Holton (center), in 1911, appears reserved and dignified. Although she experienced the abuses of slavery, it is told that very few things ruffled her, and she maintained a strong moral compass through it all. Beatrice Holton (left) died as a teenager, and Irma Holton (right) married Rufus Crawley and had nine children. Irma was very family oriented and was said to show up with a gift when anyone even remotely related to her got married. (Photograph courtesy of Doris Woods.)

Three generations of Holtons are on the front porch of their Tenth Street house in 1931. Grandmother Mary Holton is on the left of her oldest grandchild, Birdie Young, holding six-month-old Chuck Holton. Frank Holton, Chuck Holton's brother, is in the rear. (Photograph courtesy of Chuck Holton.)

Chuck and Frank Holton spent a lot of time at Lapham Park in 1937, when this photograph was taken, going over in the morning, coming home for lunch, returning in the afternoon, walking home for supper, then going back to the park. (Photograph courtesy of Chuck Holton.)

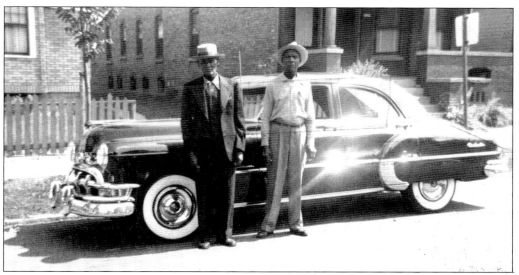

Willie Crawford (left) and his friend stand in front of the 1953 Pontiac he bought with $3,000 cash. The car salesman must have been surprised when Willie Crawford pulled out all those bills. (Photograph courtesy of Doris Wood.)

In 1948, Archibald D. Savage (left) and Mattie Savage moved 5 of their 10 children from Memphis to Milwaukee in search of better educational opportunities. Education was key to the Savages, and each of their 10 children attended a least one year of college, most earning an undergraduate degree, and three earning advanced degrees. Savage was the first African American licensed car salesman in Milwaukee, telephoning clients from his Eighth Street home to sell cars for the Nash Automobile Factory located at Holton Street and Capital Drive. He was also a self-taught professional photographer, sold real estate part time, and, after graduating from a seminary in 1966, spent his last 29 years as an ordained minister. On January 12, 1996, Mattie Savage, at 92, was a special guest of the National Aeronautics and Space Administration and became the first African American to watch a shuttle launch from the area reserved for the families of the flight crew and other astronauts. Savage's reaction to the launch was "If I was a young woman now, I think I would enjoy being an astronaut." (Photograph courtesy of Mary Savage-Mitchell.)

Brookie McClain (holding the infant Earleen) and her husband Buffus McClain, not pictured, migrated in 1938 from Philadelphia, Mississippi, to Milwaukee with their two young children to join his father. (Photograph courtesy of Ethelen Sartin [née McClain].)

Christmas is a special time for families to get together. The three girls proudly show off the new dolls they got from Santa in 1943. From left to right are (first row) Bonnie Ware (née McClain) and Earleen Campbell (née McClain); (second row) Ethelen Sartin (née McClain) ; (third row) Buffus McClain, Brookie McClain (née Bayolor), and the infant Lavern Shadd (née McClain). The McClain family also had three boys (not shown): Charles, Lonnie, and Rudy. (Photograph courtesy of Ethelen Sartin [née McClain].)

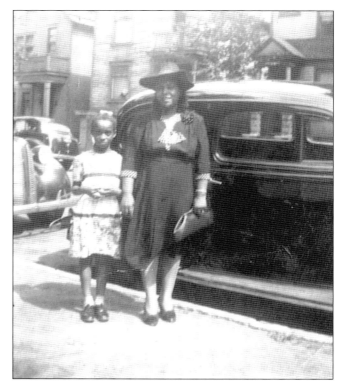

Ethelen (left) and Brookie McClain stand in front of Buffus McClain's Chevrolet in 1947, ready to go leave on a Sunday outing. Ethelen went to Milwaukee Girls' Technical Junior High School, where she had classes in English, history, citizenship, math, and sewing. She sewed her own graduation dress. (Photograph courtesy of Ethelen Sartin [née McClain].)

Ethelen Sartin (née McClain), the first African American nurse hired at Milwaukee Sanitarium, works at her desk in 1958. She went to North Division High School, two years of junior college, and received her licensed practical nurse degree from Milwaukee Area Technical College. (Photograph courtesy of Ethelen Sartin [née McClain].)

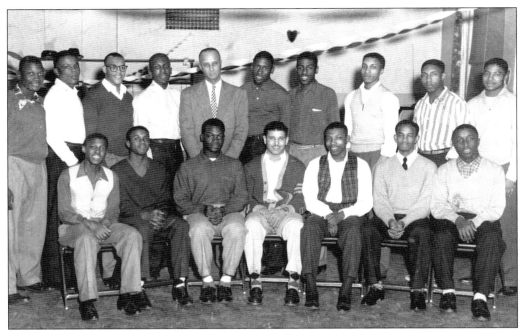

A Mr. Cheeks, back row, fifth from the left, chaperones his young men in the Lapham Park Social Center Boys Club at a Valentine's Day dance in the late 1940s. (Photograph courtesy of Larry Miller.)

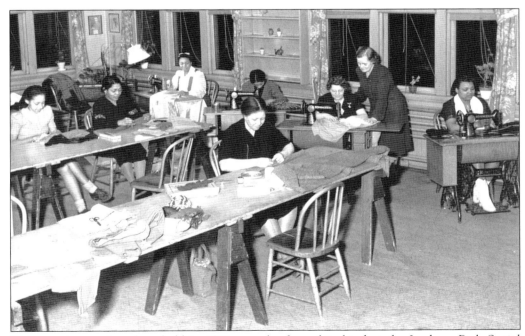

This evening sewing class, held in 1941, was the first of its kind at the Lapham Park Social Center. It offered women the chance to work on treadle sewing machines. (Photograph courtesy of Larry Miller.)

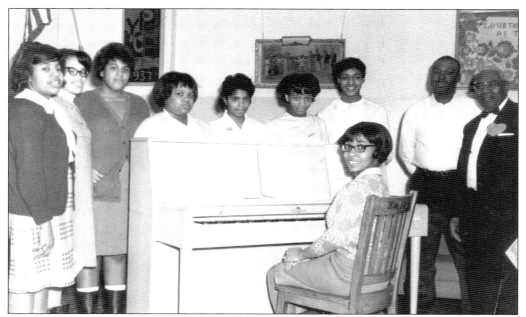

The Lapham Park Social Center supported a senior choir, a men's band, and a glee club, with the glee club shown here in this undated photograph. (Photograph courtesy of Larry Miller.)

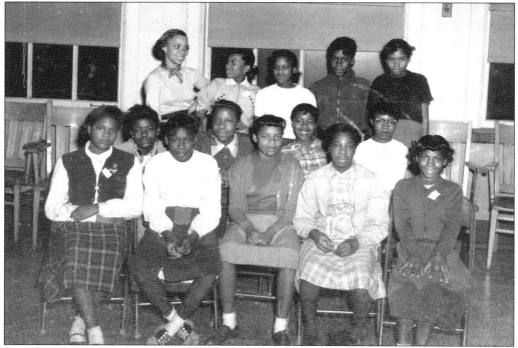

Ethel Brunner (née Clifford) stands with the Lapham Park Girls Club. (Photograph courtesy of Larry Miller.)

Young girls frolic in their swimsuits at Bradford Beach under the supervision of three women. (Photograph courtesy of Larry Miller.)

In the 1920s, the Lapham Park Social Center sponsored many activities for young girls, including the Girl Scouts. (Photograph courtesy of Larry Miller.)

Seven

EMPLOYMENT
WE ARE MARCHING

In the early 1900s, most African American women were limited to domestic work. An early morning trolley ride brought them to their employer's door by 6:30 a.m., and they worked until the evening meal was served, usually around 6:00 p.m. Meal preparation was labor intensive, as were all the other tasks typically included in the job description of a domestic servant. The laundry, for instance, took three days, first washing and rinsing, then hanging it to dry for a day, and then ironing. In the 1920s and 1930s, domestics earned 20¢ per hour; by 1945, the rate had increased to 50¢ per hour.

Here is how Ardie Halyard, founder of Columbia Savings and Loan, describes her job-hunting experiences in Milwaukee in 1923: "My search for work proved to be a distressing experience. After the worker in the employment office had exhausted her list of companies to be called with the question 'Will you take colored?' I was offered employment only at Goodwill Industries. There I sorted bags of material coming from donors, a job that any able bodied could do, but it was a bit hard for one of 96 pounds. I accepted the work without complaint; after all I thought it was only a means to an end. I made it a game and worked to see how many bags I could sort in a day. The pay was 25 cents an hour."

During World War II, young men only had to be 15 in order to work at the plants, and when young men reached the draft age, many went into the armed forces. The jobs paid a good wage, and once young men started working, it was difficult to motivate them to go back to school.

After the war, however, many returning veterans used the GI Bill to finish their education. African Americans who graduated from college found professional positions in teaching, social work, and the government. Howard Fuller said it well: "The victories are that people dealt with that [discrimination and poverty] and created a positive environment where people like Howard could succeed."

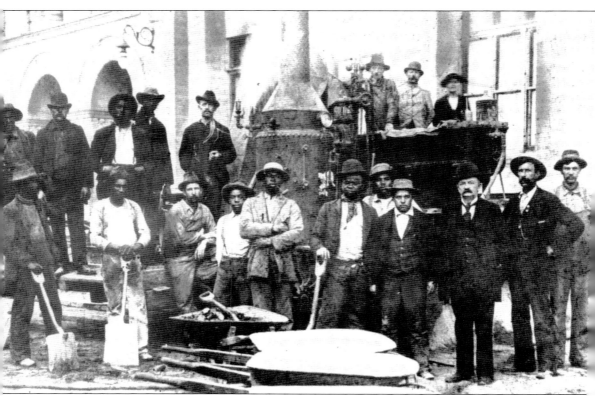

African Americans working as mason helpers pose in front of Milwaukee's city hall sometime during 1896. The wide shovels they are holding work well for shoveling sand and coal. Milwaukee's city hall, a major landmark in the city, is undergoing a major exterior renovation in 2006, a total of 110 years after this photograph was taken. (Photograph courtesy of Historic Photograph Collection/Milwaukee Public Library.)

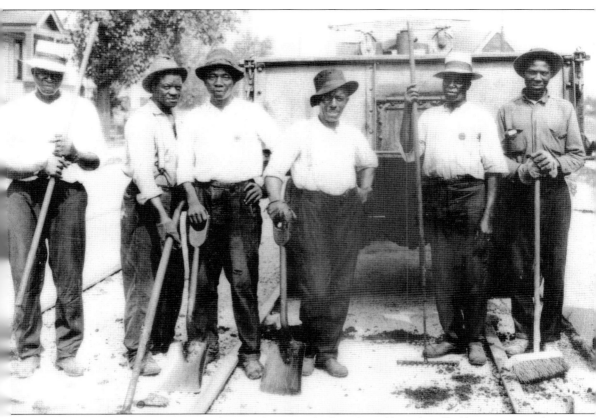

Gandy dancers hold the tools of their trade—Gandy shovels and long-handled brooms to work on the streetcar tracks here in Milwaukee. The shovel is named for the Gandy Tool Company of Chicago, Illinois, which manufactured it. The head of the shovel was used to measure the distance between the rails (four feet) and also to measure the distance between the ties. The shovel was strong enough to pry the tie up against the rail as the spike was driven home. The crews sang songs and chants, sometimes standing and balancing on the handle. That is where the appearance of a "dance" came from. (Photograph courtesy of Historic Photograph Collection/Milwaukee Public Library.)

Domestic workers in the 1920s wore white or light colored dresses for the morning work, and darker, more formal uniforms for the late afternoon. This woman might have dropped off her child at St. Benedict the Moor and may be planning to take the trolley to start her day as a domestic. Mary Young's mother did domestic work for the Weinbergs, who had a store on Third Street. Mary recalls that the two families had a close relationship, with the children doing sleepovers at each other's homes. The women who worked domestic jobs brought contributions of money and even land, donated by their white employers to support the Bronzeville churches. (Photograph courtesy of St. Benedict the Moor Church.)

Sylvester Hurd, a 1944 graduate of St. Benedict the Moor High School, joined the Tuskegee Flight Program during World War II and died in a training accident. (Photograph courtesy of St. Benedict the Moor Church.)

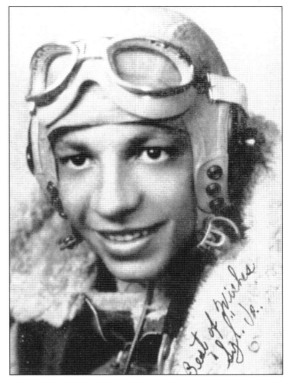

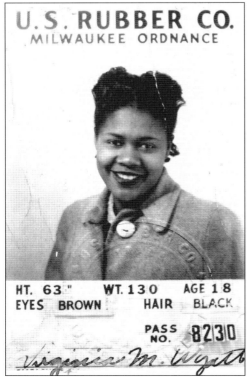

Virginia McKinney worked at the Allis Chalmers Defense Plant as a trucker delivering materials on hand trucks to workstations in the plant. Later during the war, she worked at Signal Battery. Whites were hired first for defense jobs, then blacks. The job at Signal Battery "went out just as fast as the war did." The plant closed the day World War II ended. (Photograph courtesy of Virginia McKinney.)

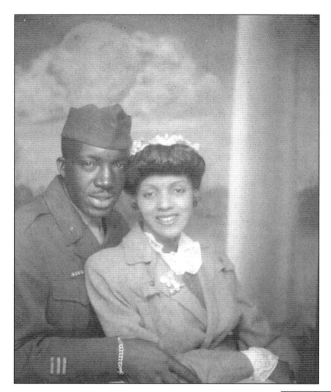

The handsome couple, James and Justine Coleman, enjoyed some precious time together during the war. James was one of the many African American men and women from Bronzeville who served in all-black units during World War II. (Photograph courtesy of Virginia McKinney.)

Nate Harris trained at the United States Great Lakes Naval Training Base in Waukegan, Illinois, in 1944. He served two and a half years in the Seabees, helping construct airfields, roads, and hospitals. Units were segregated then, and Harris served in an all-black unit with white officers. After the war ended, he played on the navy football team in Manila, then was shipped back to San Francisco where he was discharged. (Photograph courtesy of Bob Harris.)

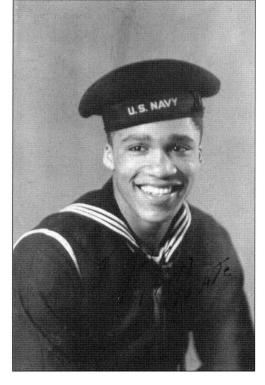

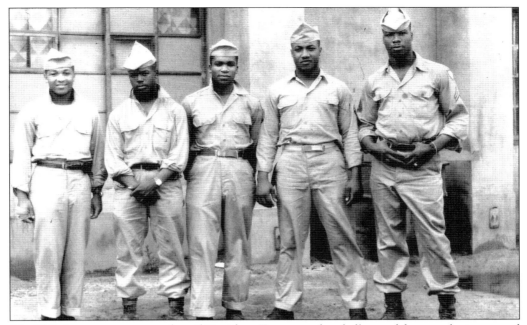

The U.S. Army was segregated until President Truman ordered all armed forces to be integrated in the late 1940s. Bob Harris, third from left, recalls, "It was very strange to go to Japan and Korea representing the United States and have the people ask 'where are the white soldiers?'" (Photograph courtesy of Bob Harris.)

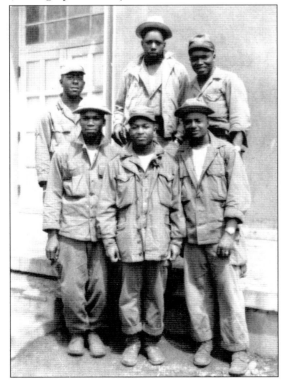

Bob Harris is shown here in Absom City, Korea, on May 10, 1945. He and his brother Nate Harris, both athletes with sports credentials earned while in the armed service, returned to Wisconsin and enrolled in University of Wisconsin-Madison. They were denied athletic scholarships because the university was on a strict quota system, handing out a very limited number of scholarships to African Americans. Robert Harris, their father, encouraged the brothers to go to college in spite of their disillusionment. (Photograph courtesy of Bob Harris.)

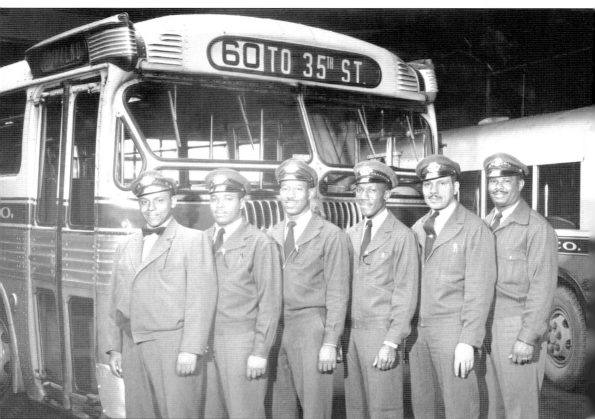

The hiring of these men as bus drivers for the Milwaukee Transit Company was a major breakthrough for the African American community. The black bus drivers usually were scheduled to drive just on the North Side of Milwaukee, although they were occasionally given South Side routes. It was not uncommon for white transit riders to have a negative reaction to the new black bus drivers. Management of the transit company hired men who had good customer service skills and dressed well. The men are, from left to right, Bill Brenner, unidentified, ? Pruitt, J. C. Thomas, Milton Coleman, and Jack S. Patterson. (Photograph courtesy of Historic Photograph Collection/Milwaukee Public Library.)

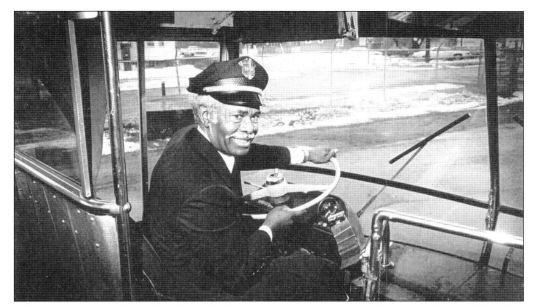

Jack Patterson's smile made riding the bus a pleasant experience. Patterson drove Milwaukee County buses for 30 years without any chargeable accidents and was an instructor of new drivers for three years. He was the first African American bus driver in the city, starting his route on September 10, 1945. (Photograph courtesy of the Wisconsin Black Historical Society/Museum.)

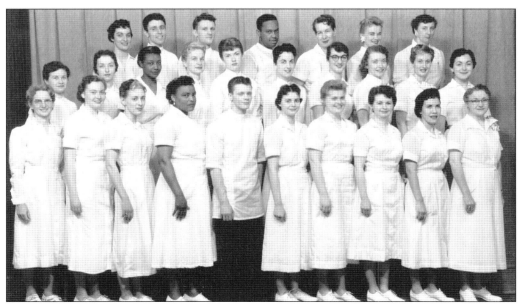

Herbert Ware was the first African American male to graduate from Milwaukee Area Technical College with a degree in cosmetology in 1956. His grandfather was an Irish slave owner, and Ware's brothers and sisters all had beautiful, wavy hair. He has been teaching in the cosmetology department at Milwaukee Area Technical College since 1963 and is an expert in treating curly hair. His slogan "Hair by Ware" is a catch phrase in the African American community. (Photograph courtesy of Herbert Ware.)

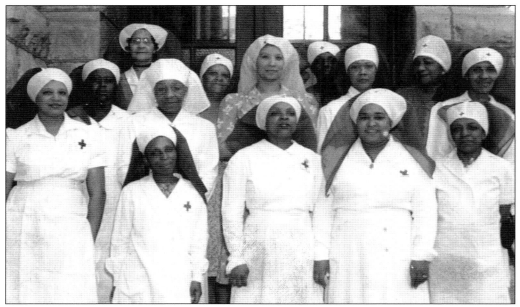

The Red Cross Nursing Service provided health care to Bronzeville residents. Many of the services were segregated during this time, with black nurses serving only black patients. Nursing was one of the few career options open to African American women. A Mrs. Reed (left, in the back, with glasses) was the leader of this Lapham Park Social Center Red Cross group. (Photograph courtesy of Larry Miller.)

Florence Persons had been a nurse at Milwaukee County Hospital for 10 years when she decided that she should go back to the State Hospital in Illinois to earn her nursing degree at the age of 52. Her daughter Edith Butts says her mother "had a beautiful personality and lots of patience." (Photograph courtesy of Edith Butts.)

Dr. John W. Maxwell Sr. went to Morehouse College in Atlanta, Georgia, for his undergraduate work, and then on to Meheray Medical School in Nashville, Tennessee, for his medical degree. His brother-in-law, Wilbur Halyard, put a good word in for him, and Maxwell was hired at St. Anthony's Hospital as a physician. Later he was promoted to chief of staff and held that position until he retired in 1973. His grandson, Tony Rhodes, says, "He made a lot of opportunities for people." (Photograph courtesy of Tony Rhodes.)

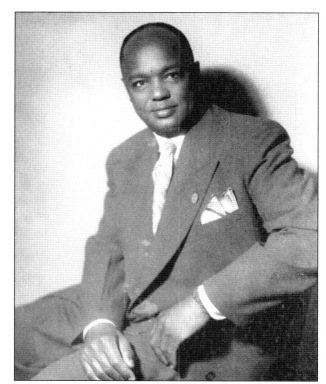

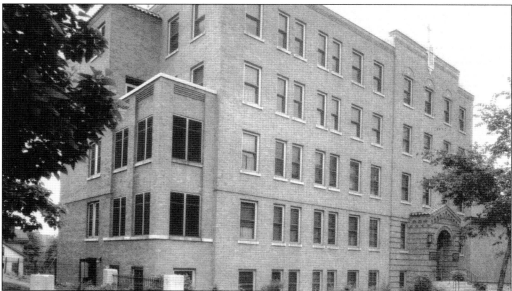

In 1929, two Franciscan sisters of the Immaculate Conception opened an infirmary with 42 beds as the only hospital that focused on the black community. In 1931, St. Anthony's Hospital was opened "to build a hospital which would serve the needs of the colored people of Milwaukee," according to a history of the Capuchins. The hospital was an integral part of the Capuchin mission, along with St. Benedict's the Moor parish and school. (Photograph courtesy of St. Benedict the Moor Church.)

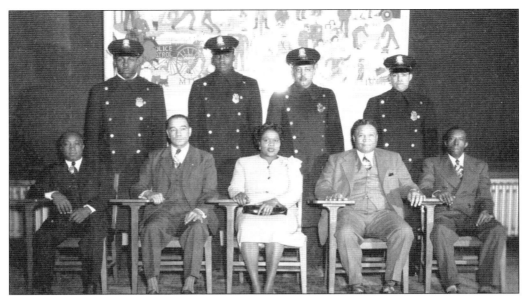

Police officers with the old-style knee-length overcoats called "bennies" gather in the old police academy classroom in the Safety Building. From left to right they are (first row) unidentified, Lonnie Spencer, Vernice Gallimore (the first black policewoman), Calvin Moody, and unidentified; (second row) Felmers Chaney, Andy Coleman, Al Wright, and Charles Benford. Felmers Chaney was considered a natural born leader, both as a second lieutenant during World War II, and in the police department. (Photograph courtesy of Milwaukee Police Department.)

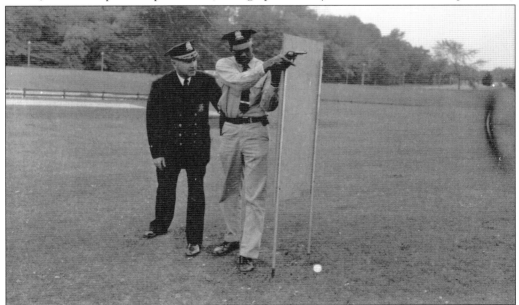

An African American officer gets some gun handling tips from his instructor at the Milwaukee Gun Club shooting range located at the north end of Lake Park, east of Lincoln Parkway. Promotions for black officers were hard to come by in the 1940s. Felmers Chaney was told "The chief would like to 'make you' but is afraid of what the whites would say." (Photograph courtesy of Milwaukee Police Department.)

Eight

LEADERS
LEAD ME, GUIDE ME

The accomplishments of leaders like William Thomas Green, James Dorsey, Vel Phillips, Hollis B. Kinner, and Isaac and Marcia Coggs are a testimonial to the vitality of the Bronzeville community and an inspiration to those who followed them.

William Thomas Green came to the United States in 1884 and worked as a waiter at the Plankinton Hotel. When he was denied a seat on the first floor of the Bijou Opera House, he sued, and five years later, a state law was passed prohibiting race barriers in public institutions. Green earned his law degree from University of Wisconsin-Madison in 1892 and established a law practice serving both black and white clients. He believed in integration and successfully lobbied against two successive bills in the state legislature that attempted to ban mixed marriages.

James Dorsey, "the mayor of Bronzeville," was born in Missoula, Montana, in 1897 and earned his law degree from Montana State University Law School. He moved to Milwaukee and established his law practice in 1928, during the depths of the Depression. At that time, the white majority carefully gerrymandered the wards to split the black vote and ensure that white candidates won. In spite of this inequity, he came very close to winning an election for the Sixth Ward alderman.

Hollis B. Kinner came to Milwaukee from Gainesville, Georgia, in 1897. He opened a string of businesses, including the Alberta Villa hotel in 1917, a commercial laundry in the 1920s, Kinner Sausage Company in 1929, and Kinner Dixie Barbeque Restaurant in the 1930s. A man of many talents, he graduated from the Milwaukee School of Engineering in 1923 and taught automotive engineering. He was also a local correspondent for regional papers like the *Chicago Defender*, active in local politics, a founding member of the Milwaukee Branch of NAACP, on the executive board of Urban League, and president of the Milwaukee Negro Business League.

These pioneering leaders set the stage for the next generation of African American leaders out of Bronzeville, who have changed the face of Milwaukee with their contributions. Just a few of these notable change agents are featured in this last chapter as a reminder of the continuing influence of the Bronzeville era on the history of the Milwaukee community.

In 1952, Isaac N. Coggs was one of the first African Americans elected to the state legislature, where he served six terms. He was elected to the Milwaukee County Board in 1964, where he was the first African American chairman of a legislative committee and was a leader in fighting housing discrimination in the early 1960s. (Photograph courtesy of Elizabeth Coggs-Jones.)

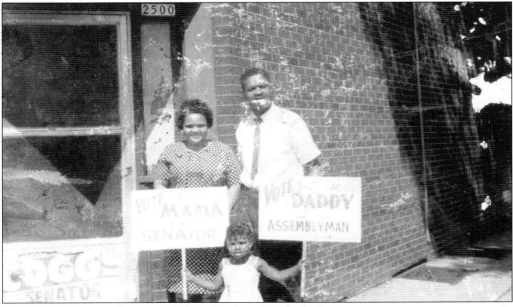

Isaac Coggs, Marcia Coggs, and their daughter Elizabeth Coggs were veteran campaigners. In 1976, Marcia was the first African American woman elected to the Wisconsin state legislature. Elizabeth Coggs-Jones was elected to the Milwaukee County Board of Supervisors in 1988, and was reelected in 1992, 1996, 2000, and 2004. Isaac Coggs liked to say, "Marcia, together we stick but divided we are stuck!" (Photograph courtesy of Elizabeth Coggs-Jones.)

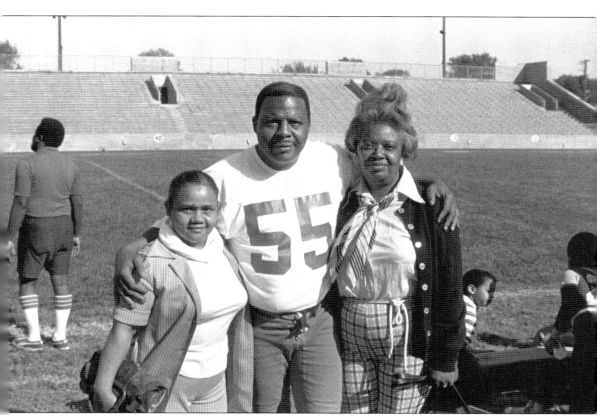

Marcia Coggs (left), O. C. White, and Bernice Rose warm up for the annual "Over the Hill Gang" fund-raiser and football game at Rufus King's North Stadium. The game, which was between former Rufus King and Lincoln alumni and a team fielded by Milwaukee County Sheriff's Department, city of Milwaukee firefighters, and others, was to raise money for youth scholarships. Not everyone trained for the game, so there were a lot of substitutions. (Photograph courtesy of Bob Harris.)

Pauline Coggs, wife of attorney Theodore Coggs, was a school social worker for the University of Wisconsin Extension. As director of the Urban League during the Roosevelt years, she became a friend of Eleanor Roosevelt. One of her skills was working with community groups in annual planning sessions. (Photograph courtesy of Chuck Holton.)

Layola Fields was trained at Homer G. Phillips Hospital in St. Louis and came to Milwaukee in 1938. She joined the Visiting Nurses Association, and from 1941 to 1945, was the field representative to the National Tuberculosis Association. She established "best practices" for foundry factory workers in Milwaukee and by 1948, reduced the tuberculosis death rate among African Americans in Milwaukee County by two-thirds of the 1929 rate. (Photograph courtesy of Wisconsin Black Historical Society/Museum.)

Canary Savage Girardeau was the first African American to complete the University of Wisconsin-Madison nursing program in 1955. She completed her public health nurse certification at Marquette University and earned a bachelor's and master's degree in educational psychology at University of Wisconsin-Milwaukee. She spent the early part of her health care career in Milwaukee and then took positions in Washington, D.C., and Florida, where she worked for the state's Department of Health. (Photograph courtesy of Mary Savage Mitchell.)

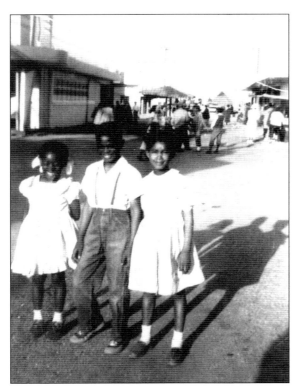

Anita Knox (left), Howard Fuller, and Dian Wyatt enjoy a family outing at Riverview Amusement Park in northern Illinois in 1950. The Riverview Amusement Park is no longer in existence. Knox, Fuller, and Wyatt were childhood friends in Bronzeville. (Photograph courtesy of Virginia McKinney.)

Howard Fuller is a professor of education and the founder and the director of the Institute for the Transformation of Learning at Marquette University. A national figure in the ongoing debate about how to improve public education, Fuller was previously the superintendent of Milwaukee Public Schools, director of Milwaukee County Department of Health and Human Services, and a dean at Milwaukee Area Technical College. (Photograph courtesy of Howard Fuller.)

Reuben Harpole is the institutional memory of Milwaukee's Bronzeville. His ability to recall names, even phone numbers, of people is known throughout the community. A person who believes in networking, he has been talking to people in the community from the time he was a small boy, taking hours to return from an errand because of many conversations on the way. He is program officer of Sankofa-Youth Development, at the Helen Bader Foundation, and has a lifelong commitment to the youth of Milwaukee. (Photograph courtesy of the Helen Bader Foundation.)

Bob Harris was the first African American high school basketball referee in the state of Wisconsin, served as a commissioner of the Milwaukee Police and Fire Commission, and is a tireless community volunteer. He is involved in the day-to-day management of the Milwaukee Police Athletic League, an important resource for Central City youth. (Photograph courtesy of Paul Geenen.)

James Harris, shown here as an anti-aircraft gunner in the South Pacific in 1942, hired attorney James Dorsey and brought legal action to gain acceptance as a member of the Bricklayer's Union, becoming the first African American in that union. His brother Bob Harris sent money back from his U.S. Army paychecks while serving in Korea to help his brother hire the best attorney town. (Photograph courtesy of Bob Harris.)

James Harris, as the first African American member of the Bricklayer's Union, laid the first brick of the Wisconsin Department of Natural Resources building on North Avenue and Martin Luther King Drive. (Photograph courtesy of Bob Harris.)

Bernice Copleand Lindsay, born in Winchester, Indiana, was the first African American to graduate from the Ohio State University School of Journalism. She worked as a social worker in Indianapolis, Indiana, before moving to Milwaukee in 1928. She was the first African American executive director of Milwaukee's YWCA but lost her job because she did not agree with the manner in which black women were served. The practice was to turn black women out after two weeks residence while the white residents were allowed to stay as long as they wished. In 1933, Lindsey started the Mary Church Terrell house at 3002 North Ninth Street, where young women could live and receive an education. She was a member of both city and state human rights commissions. The city of Milwaukee has a street named after her, and a successful housing development between Seventeenth and Twentieth Streets, called Lindsay Heights, is named for her. (Photograph courtesy of Wisconsin Black Historical Society/Museum.)

Virginia McKinney established Dian Uniforms, the first and only African American–owned uniform shop in Wisconsin. In business for four years, it was just becoming profitable when the 1960s riots destroyed Third Street as a business district. McKinney used such guerrilla marketing methods as donning a white uniform and visiting day care operations and hospitals—or any place where uniforms are worn—and dropping off flyers advertising her store. (Photograph courtesy of Paul Geenen.)

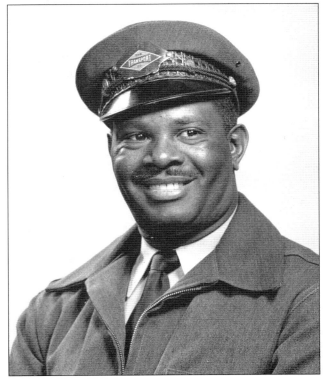

Jack S. Patterson spent four years welding at A. O. Smith during World War II. In 1945, the manager of the Milwaukee Transport Company, a Mr. Cumberline, got the union's approval to hire Patterson. The union's approval was a breakthrough, as it was common practice at the time to exclude blacks from union membership, which resulted in blacks crossing picket lines during labor unrest. Patterson became the first African American bus driver in Milwaukee County. (Photograph courtesy of Wisconsin Black Historical Society/Museum.)

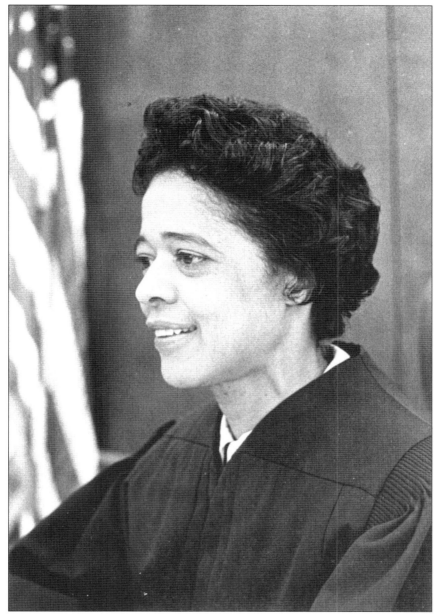

Using a scholarship from the Elks and money raised in the community by the barber Eugene Mathews, Vel Phillips earned her undergraduate degree at Howard University, in Washington, D.C. In 1951, she earned a law degree from the University of Wisconsin-Madison, becoming the first African American woman to do so. She and her husband, W. Dale Phillips, were the first husband and wife attorney team to practice in the federal court. In 1956, she became the first African American woman to serve on the Milwaukee Common Council, where she served for 15 years. In the 1970s, she became the first woman judge in Milwaukee County and the first African American to serve in Wisconsin's judiciary. In 1978, she was elected as secretary of state of Wisconsin, again being the first African American to do so. (Photograph courtesy of Wisconsin Historical Society.)

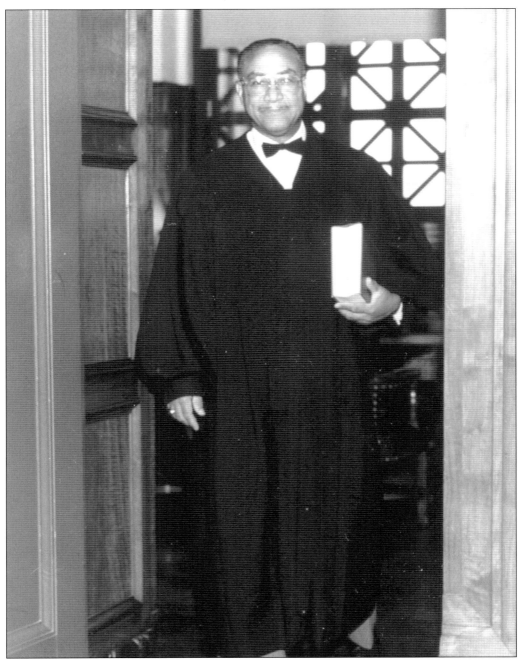

Clarence Randolph Parrish received a degree from St. John's School of Law in Brooklyn, New York, and a masters degree in law from the University of Wisconsin-Madison in 1952. His family lived on Ninth Street, directly across the street from the Mary Church Terrell Club. This social club elected Clarence Parrish the "Mayor of Bronzeville." He was appointed to Milwaukee County Circuit Court in 1980 and held that position until he retired in 1992. He was the first African American to win a contested judicial race. (Photograph courtesy of Sheila Parrish-Spence.)

Archibald Savage studied at Moody Bible Institute and was ordained in 1966. He was the Visitation Minister at Calvary Baptist Church and as part of his responsibilities gave many services at Plymouth Manor, the nursing home at Sixth and Walnut Streets. Pastor Savage was a mentor for Judge Clarence Randolph Parrish when Judge Parrish was studying for the ministry. (Photograph courtesy of Mary Savage-Mitchell.)

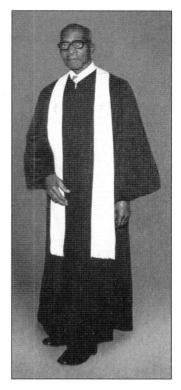

Sylvester Sims is an accomplished, self-taught, artist who has received awards from juried art competitions and has his work in both public institutions and in private collections. He studied watercolor technique with Earl Gessert and at the (old) Layton School of Art. He continues to work on his artistic techniques by taking classes and is an art teacher himself. (Photograph courtesy of Sylvester Sims.)

ACROSS AMERICA, PEOPLE ARE DISCOVERING SOMETHING WONDERFUL. *THEIR HERITAGE.*

Arcadia Publishing is the leading local history publisher in the United States. With more than 3,000 titles in print and hundreds of new titles released every year, Arcadia has extensive specialized experience chronicling the history of communities and celebrating America's hidden stories, bringing to life the people, places, and events from the past. To discover the history of other communities across the nation, please visit:

www.arcadiapublishing.com

Customized search tools allow you to find regional history books about the town where you grew up, the cities where your friends and family live, the town where your parents met, or even that retirement spot you've been dreaming about.